Introduction

While a blank canvas holds all the possibility in your creative world, surface textures offer an inspirational way to begin a piece of artwork. Whether you are painting, sculpting, are interested in paper or are into mixed-media, the forty-five techniques in this book will give you a basis for making art you'll enjoy creating and will love to look at (and in some cases, touch). The concept of this book was borne from our first book, *Image Transfer Workshop*. In it, the backgrounds we created for the image transfer techniques intrigued our students, who wanted to learn the background techniques we had used. We were (and continually are) energized by their enthusiasm, which, in turn, sparked this creative journey.

We think the strong point of this book is learning the techniques and then combining them to create a unique surface that has both history and mystery. People will wonder "how you did that" instead of instantly identifying the method. Some of the techniques we tried were pretty wild. The **Shaving Foam technique** (page 84) was goofy and fun, and the **Pulled Paper technique** (page 50) had us singing the *Jeopardy* song to time the process. The **Salt resist technique** (page 100) had us collecting all kinds of salt, and the technique for **Making Your Own Specialty Gels** (page 34) really got us laughing.

As a bonus, we pushed the boundaries of the techniques and tried them in some innovative combinations. This artistic stretching has resulted in more than 250 variations. We hope you have as much fun coming up with new and different textures and surfaces as we did.

On a practical note, we try to use a lot of common materials and tools. Some products may give you different results, and we cover this in tips and troubleshooting sidebars. As artists, we both have very different styles, and the artwork displayed throughout demonstrates how these techniques can be used for all styles of painting. Many of these techniques may be adapted for fabric work, book arts, scrapbooks, journals, quilting, sculpture, jewelry and many other crafts.

The more techniques you know, the more tools you have to work with. You may employ only a few techniques in one project, but you have the resources to pick and choose the methods that will best fit your vision. Our wish is that you will explore all the possibilities, including the unexpected ones. We encourage you to experiment, create and play and share your discoveries at imagetransferworkshop.com.

How to Use This Book

Each technique has its own special qualities and characteristics—from the proper surfaces to particular materials and special steps and quirks. The following describes how the techniques are set up so you know what to look for and where to find it.

Technique Introduction

These brief introductions explain what you can expect from each technique, some fun things to do with it and possibly unexpected sources for the materials.

Materials & Tools

These lists describe the supplies you will need to complete each surface technique. The sources are varied, ranging from kitchen essentials to fine art supplies. Read the lists carefully and gather all your materials prior to starting the process.

Surfaces

These lists describe which surfaces the techniques will work on. Surfaces can range from panels or boards to papers and fabric. Certain techniques work only on paper, and some must be applied only to a rigid surface. Check these lists for the appropriate surfaces.

Archival Quality

The term "archival" refers to the method, process or products that assure longevity for the art or craft.

Excellent archival quality assures that the materials used are a professional grade and that pigments have a superior lightfastness. The art or craft will last many decades.

Good archival quality means the materials and products will not erode or break down for at least twenty-five years.

Poor archival quality means the materials are not stable and are prone to fading or breaking down within months or years.

You can improve the archival quality of your work by using the best-quality products, treating with an isolation coat of gel medium and using archival varnish.

Tips

The tips can assist you in creating the surface you desire. Some are reminders of paint consistency, and others may be specific tools or products that will make your outcome more successful.

Troubleshooting

What happened, and why didn't it work? We will point out some of the common pitfalls in each technique and suggest possible solutions.

Variations

Almost every technique has possible alternative materials, tools, colors or processes. We have completed samples for each technique to both instruct and inspire. Many samples illustrate how combining techniques can create a whole new surface. Some examples include image transfer techniques over the surface treatments. You may want to refer to our first book, *Image Transfer Workshop*, for further instruction and inspiration.

Surface Treatment Workshop

Explore 45 Mixed-Media Techniques

Darlene Olivia McElroy and Sandra Duran Wilson

NORTH LIGHT BOOKS

Cincinnati, Ohio

www.CreateMixedMedia.com

20 19 18 17 16 11 10 9 8 7

DISTRIBUTED IN CANADA BY FRASER DIRECT
100 Armstrong Avenue
Georgetown, ON, Canada L7G 5S4
Tel: (905) 877-4411

DISTRIBUTED IN THE U.K. AND EUROPE BY
F+W MEDIA INTERNATIONAL
Brunel House, Newton Abbot, Devon, TQ12 4PU, England
Tel: (+44) 1626 323200, Fax: (+44) 1626 323319
Email: postmaster@davidandcharles.co.uk

DISTRIBUTED IN AUSTRALIA BY CAPRICORN LINK
P.O. Box 704, S. Windsor NSW, 2756 Australia
Tel: (02) 4577-3555

Library of Congress Cataloging in Publication Data
McElroy, Darlene Olivia.
 Surface treatment workshop : explore 45 mixed-media techniques / by Darlene Olivia McElroy and Sandra Duran Wilson. -- 1st ed.
 p. cm.
 Includes index.
 ISBN 978-1-4403-0824-6 (pbk. : alk. paper)
 1. Handicraft. 2. Mixed media painting. 3. Coatings. I. Duran Wilson, Sandra. II. Title.
 TT157.M4457 2011
 745.5--dc22
 2010038110

www.fwmedia.com

EDITED BY Julie Hollyday

COVER BY Geoffery Raker

LAYOUT DESIGN BY Marissa Bowers

PRODUCTION COORDINATED BY Greg Nock

PHOTOGRAPHY BY Christine Polomsky

METRIC CONVERSION CHART

TO CONVERT	TO	MULTIPLY BY
Inches	Centimeters	2.54
Centimeters	Inches	0.4
Feet	Centimeters	30.5
Centimeters	Feet	0.03
Yards	Meters	0.9
Meters	Yards	1.1

Dedication

From Darlene Olivia McElroy

To Dave, my dear husband and ballast. To my wonderful brother, Mike, who has supported my art endeavors and encouraged me to follow my creative dreams. And to my little sister, Denise, who I lost in 2010 and will always miss.

From Sandra Duran Wilson

To Mark, my wonderfully talented and creative husband: I thank you for keeping me inspired and living life in full spectrum color. To all the young artists just beginning to choose their paths: Live your dreams and hold them dear; they are precious.

Acknowledgments

Thank you to Bonnie Teitelbaum, our great assistant and asset; you kept us on track once again and provided us with your unique perspective. We couldn't have done it without you.

On the incredible F+W team, we would like to thank Tonia Davenport for getting this book on board; Julie Hollyday, our wonderful editor; and Christine Polomsky, our talented photographer. You all made it fun and easy.

We would also like to thank our students, who gave us the inspiration to create this book. You kept us exploring and experimenting, and we hope to keep coming up with more innovative ways to play.

About the Authors

Sandra Duran Wilson is an artist and a scientist. She loves looking at the world from many perspectives. When she was a little kid, she would stand on her head and look at the world upside down; today when she wants a new perspective, she still does this.

Sandra was deeply influenced by her early years growing up near the border of Mexico, listening to the family stories and painting with her great aunt, Santa Duran. Her travels and studies with indigenous healers have also influenced her work. She has both a fine art degree and a science degree from the University of New Mexico, both which provide the foundation for her explorations and experiments in art.

Sandra's home and studio are in Santa Fe, New Mexico, and she collaborates in art, love and life with her husband and feline friends.

Darlene Olivia McElroy comes from an old New Mexico family of storytellers and artists. She began making art the first time she found a wall and a drawing instrument. Her grandfather, a painter on Catalina Island, was her mentor and taught her to play and experiment with art.

Darlene attended the Art Center College of Design in Pasadena, California, and then worked as an illustrator both in the United States and in Paris. The influence of her background and her travels is evident in her work.

She lives and works in Santa Fe, New Mexico, and creates new life stories with her husband, Dave, and their four dogs, Oso, Taco, Bernie and Zola.

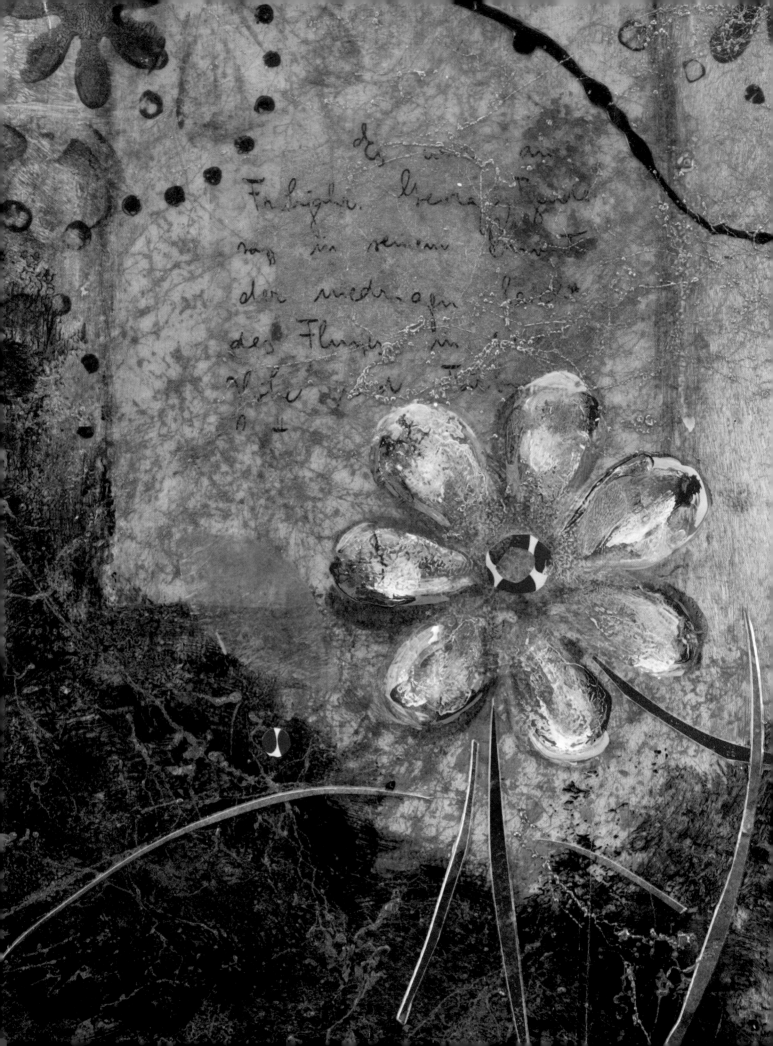

Table of Contents

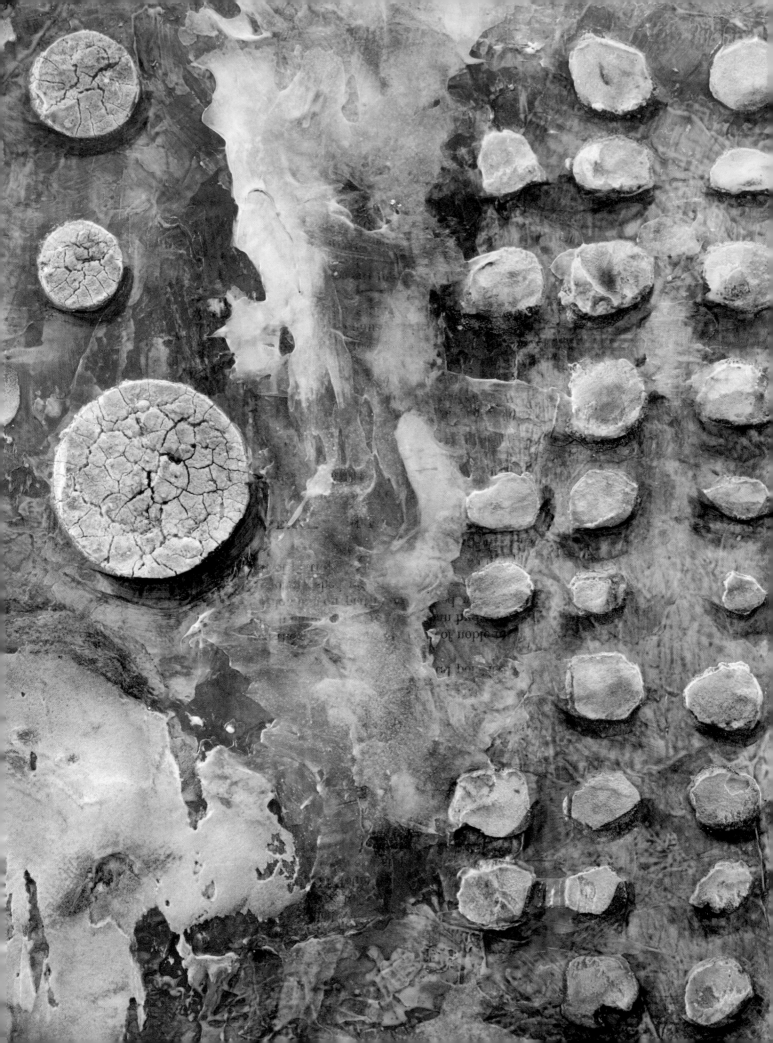

TOOLS AND MATERIALS TO GET YOU STARTED

While the techniques in this book use a variety of materials to create innovative surfaces, we make good use of some basic tools and materials you can probably find in your home or studio.

Some items you may already have in your home or art-supply stash include:
Eyedropper
Newspapers or plastic (for protecting your work surface)
Paints
Paintbrushes
Palette knife
Paper towels
Sandpaper
Scissors
Spray bottle
Stamps
Stencils

Don't let this list limit your creativity. As you'll see from the techniques, we love using what is on hand, and we love being creative with existing materials. Consider using what you have around the house, and see what it does to your art.

IMPROVING THE ARCHIVAL QUALITY OF YOUR ARTWORK

You can improve the archival quality of a finished piece of artwork by using varnish. Varnishes come in matte, satin and gloss, and your choice will alter the finished look of the piece. The type of varnish you choose—spray or painted varnish—will depend on your personal preferences and your surface texture. Spray varnish is better suited for heavy surface textures. Painted varnish tends to settle in the valleys and leaves the peaks exposed.

We typically use spray varnishes when finishing a piece because they are easy to use. A spray is much thinner than a painted varnish, so you may wish to apply eight coats or more to ensure adequate protection. If you simply wish to alter the sheen, four coats is usually sufficient. When applying spray varnishes, it is helpful to rotate the piece a quarter turn with each coat; this will ensure you cover all areas.

When using a painted varnish, be sure each coat is fully dried before applying the next. You will use fewer coats of painted varnish than you would with a spray.

Work with both varnish types outside or where there is adequate ventilation.

ADDITIVE | Stamping

Stamping is a great way to add visual interest to your art. Nothing is sacred when it comes to stamping: You can use your tennis-shoe sole, bubble wrap, vegetable netting, even your dog's paw. Although there are commercial stamps available, most are meant for use with inks and may clog up when you apply acrylic paint. Get creative and make your own, or look for stamps made specifically to use with acrylic paints.

1 Use the paintbrush to apply paint onto the stamping object.

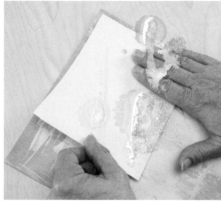

2 Press the stamp, paint side down, onto the surface.

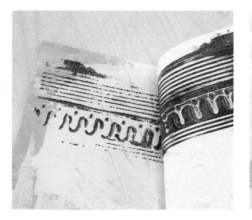

3 Release the stamp to show the pattern.

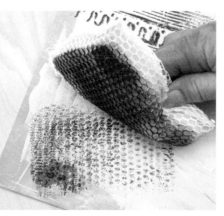

4 Repeat steps 1–3 with other stamping objects to create different patterns.

TROUBLESHOOTING

If your paint is too wet, your stamp will be saturated. If it is too dry, you will get a poor result. You can try applying glazing medium as a means to extend drying time.

Techniques

The techniques in this book are varied in their materials and purposes. By simply changing your colors and substrates or by combining techniques, you can expand your arsenal of art techniques, and you'll be able to take your art to a new level. By giving you variations on each technique, we hope to inspire you to do your own exploration. We advocate that you craft the best possible project, but don't let archival concerns keep you from experimenting. We've broken the techniques down into three categories.

Additive Techniques

Additive surface techniques are simply techniques that you apply to your surface. Most of the techniques in this book are additive. The additive techniques give you the most control over the results, and you can replicate them easier, but we encourage you to learn the rules and then break them.

Resist Techniques

Resist surface techniques are the results of one material added to or applied on top of another. These "reactions" create less predictable but interesting surfaces. They tend to be difficult to replicate exactly, but this also allows for many happy accidents.

Subtractive or Combination Techniques

This category covers a range of surface treatments, from subtractive techniques like sanding and scribing to combo techniques such as fusible web. Subtractive techniques are those that occur when you take something away from the surface; combination techniques happen when you use both a reactive and additive method together. The techniques in this section are also unique and do not replicate exactly, but this is what makes them beautiful.

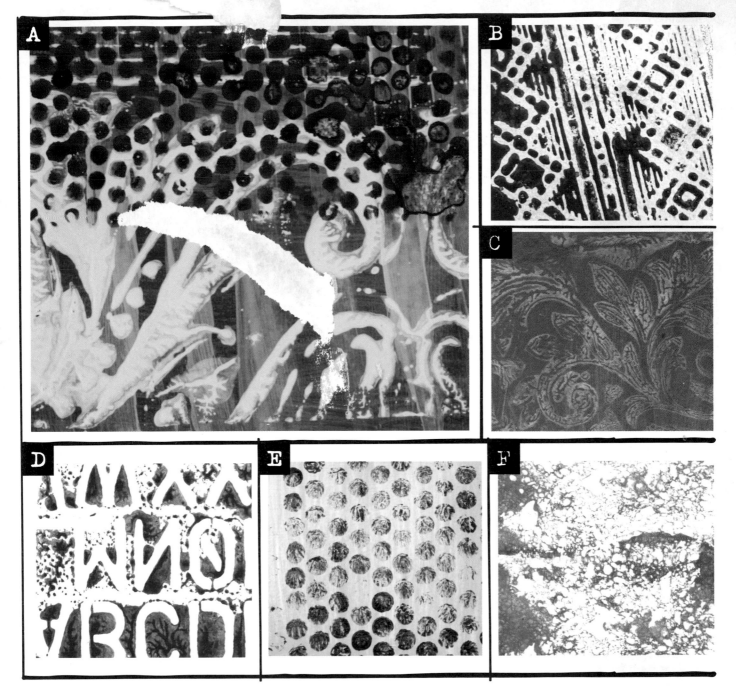

A. **Layer:** Stamp several different patterns in different colors for great layering. B. **Metallic:** Use metallic paint on the stamp or as your base for drama. C. **Subtractive:** Use the stamp to remove wet paint from the surface. D. **Stencil:** You can paint around the cutout sections of a stencil and use it as a stamp. E. **Packing Foam and Bubble Wrap:** These items are easy to find in your mail! You can also buy them in a variety of shapes, sizes and textures. F. **Sponge:** Sponges, both natural and man-made, have great texture; just be conservative with how much paint you put on the sponge at first; you can always put more on, but it is hard to get rid of too much.

ADDITIVE | Stencil

This wonderful technique gives interest both as a painting base or a design element on top of the painting. You can find stencils online, in hobby stores or in art stores, or you can create your own.

MATERIALS + TOOLS

stencils

palette knife

medium: molding paste, ceramic stucco or hard gel

acrylic paint

surface

SURFACES

canvas

metal

panel

Plexiglas

watercolor paper

ARCHIVAL QUALITY

Excellent

TIPS

For crisp edges when using paint, lay soft gel over the stencil first and then paint. Proceed to step 2.

A mixture of matte hard gel and a metallic gold gives the look of beeswax.

If excess paint or gel gets on the stencil, use that side as a stamp.

You can use spray paint as well. Lift the stencil off the surface ever so slightly to get a look with soft edges.

1 Lay the stencil on the surface. Using the palette knife, drag the medium over the stencil.

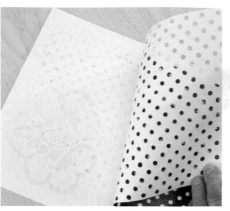

2 Pull off the stencil while the medium is still wet. You can layer stencils; just make sure each layer is dry before adding the next.

3 Lay another stencil on top of the background. This time, use the palette knife to spread the acrylic paint over the stencil.

4 Pull the stencil off and allow the paint to dry before continuing your artwork.

VARIATIONS

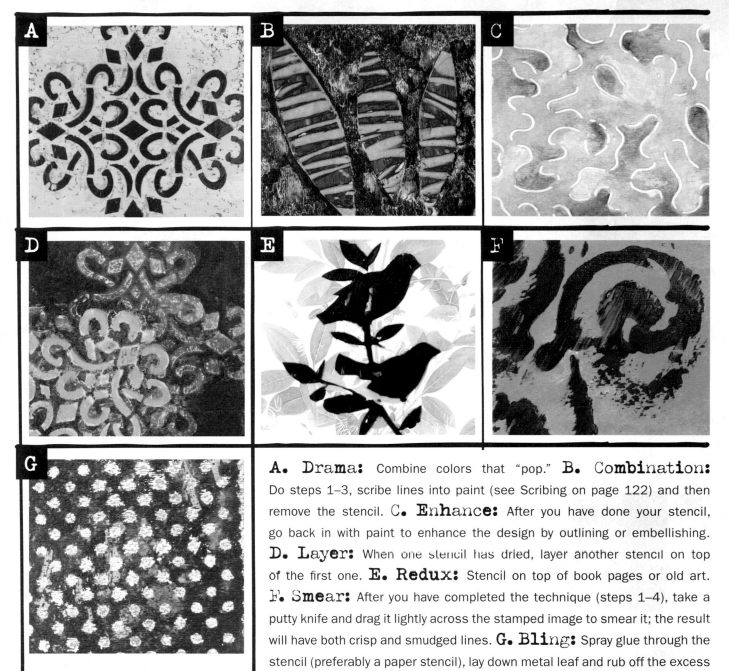

A. Drama: Combine colors that "pop." **B. Combination:** Do steps 1–3, scribe lines into paint (see Scribing on page 122) and then remove the stencil. **C. Enhance:** After you have done your stencil, go back in with paint to enhance the design by outlining or embellishing. **D. Layer:** When one stencil has dried, layer another stencil on top of the first one. **E. Redux:** Stencil on top of book pages or old art. **F. Smear:** After you have completed the technique (steps 1–4), take a putty knife and drag it lightly across the stamped image to smear it; the result will have both crisp and smudged lines. **G. Bling:** Spray glue through the stencil (preferably a paper stencil), lay down metal leaf and rub off the excess with masking tape to reveal the stencil (see Metal Leaf on page 38).

TROUBLESHOOTING

Pull your stencil off your art before the medium dries.
If it dries, your stencil will be glued to your surface.
If you are using spray glue, use a paper stencil—it is almost
impossible to get the spray glue off a plastic stencil.

ADDITIVE | Aluminum Foil

The kitchen is a great resource for art supplies. Think of this technique as an economical silver leaf. The art store-purchased silver leaf is also aluminum, but you get different outcomes with the sturdier foil, so it's another great tool to have on hand.

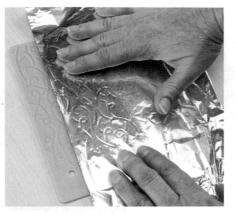

1 Put foil over the texture plate. Using your hand, rub the foil into the texture plate.

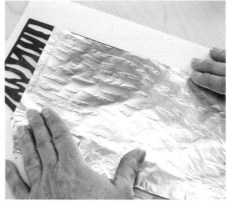

2 Place another piece of foil over the stencil and rub with your hand to imprint the texture. It helps to have some newspaper or a towel underneath.

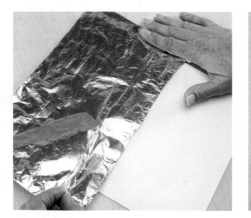

3 Using a palette knife, spread the gel medium on the surface. Put the foil over the gel medium and gently press it down to adhere it. Let the gel dry.

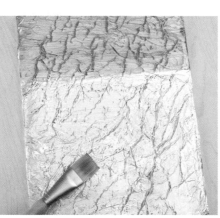

4 Using the paintbrush and desired paint, paint the foil. Allow the paint to dry completely before proceeding with the artwork.

MATERIALS + TOOLS

aluminum foil

stencils, stamps, embossed paper or texture plates

palette knife

gel medium, soft or hard, matte

surface

paintbrush

acrylic paint

SURFACES

canvas

panel

watercolor paper

ARCHIVAL QUALITY

The archival quality is excellent if you make sure you have good adhesion and use quality paint.

TIPS

Different brands and weights of foil will give you different results. I like the heavy-duty foil because it is more forgiving.

A rigid surface works best when covering large areas.

To print directly onto the aluminum foil, see the Drawing Grounds technique on page 37.

For the final finish, use a spray varnish.

VARIATIONS

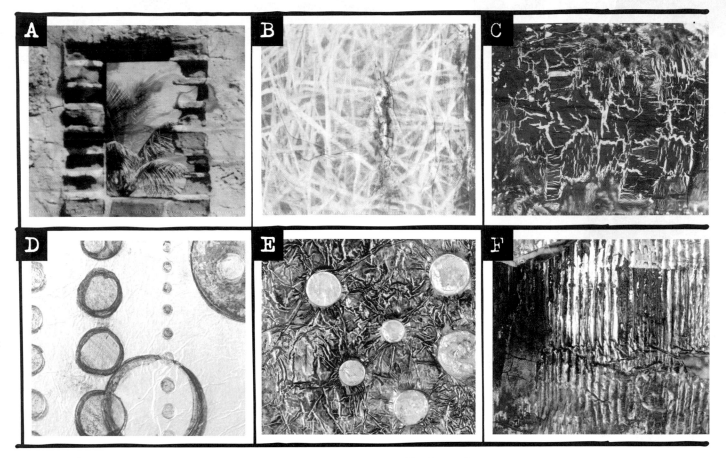

A. Print: Print an image on vellum and adhere it to the foil. **B. Magic:** Print an image on gampi paper. Spray the image with a spray fixative, and glue it to the foil. **C. Drama:** Create a glue crackle (see All-Purpose White Craft Glue on page 106) over the foil. **D. Draw:** Paint a thin layer of clear gesso over the foil, let it dry and draw on the surface. **E. Hide:** Glue your objects down, cover them with the foil and press the foil onto the objects to create prominent shapes. **F. Texture:** Put a thick layer of gel onto a sturdy surface, place the foil over it and, while the gel is still wet, gently drag a comb across the foil to create texture. Allow the gel to dry. Paint the surface and allow the paint to dry, and then sand back some areas.

TROUBLESHOOTING

Do not put gloss medium directly over the foil. I did this and then painted over that and let it dry. It turned into a gel skin with texture, which was really a nice discovery, but the paint did not stick. Create tooth by applying a layer of clear gesso to the surface, or paint directly onto the foil.

If your paint is beading, wipe it off and either wipe the foil with alcohol, spray it with a spray fixative or paint a layer of clear gesso. Reapply the paint.

ADDITIVE | Masking Tape

This simple product, which most of us have around the house, is great for creating wonderful textures. With a dark brown stain, it can look like leather. You can also use it as a resist or create gold leaf with it. If you are a whiz on the computer, you can scan and play with it.

MATERIALS + TOOLS

surface

paintbrush

acrylic paint

masking tape

scissors

SURFACES

canvas

panel

watercolor paper

ARCHIVAL QUALITY

Good to poor

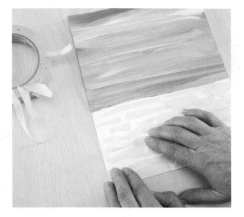

1 Paint the surface as desired, leaving an unpainted section for the tape, and allow the paint to dry. Tear or cut the masking tape and apply the pieces to the surface.

2 Using your fingers or the handles of a pair of scissors, rub down the tape to seal it to the surface.

TIPS

Every brand of masking tape has its own properties, so you might want to try several different brands to find the one you like best.

The adhesive in the masking tape will break down, so this method is not long lasting. To increase archival quality, apply a layer of acrylic medium over the surface and allow it to dry before adding the tape.

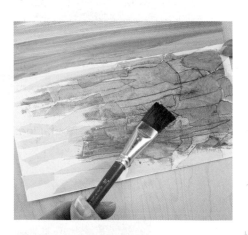

3 Use the paintbrush to apply the acrylic paints of your choice. Allow the paint to dry before adding more layers of tape and paint.

TROUBLESHOOTING

If paint beads on the masking tape, wipe off the paint and either wipe with alcohol, spray with spray fixative or add a layer of clear gesso; allow to dry. Reapply paint.

VARIATIONS

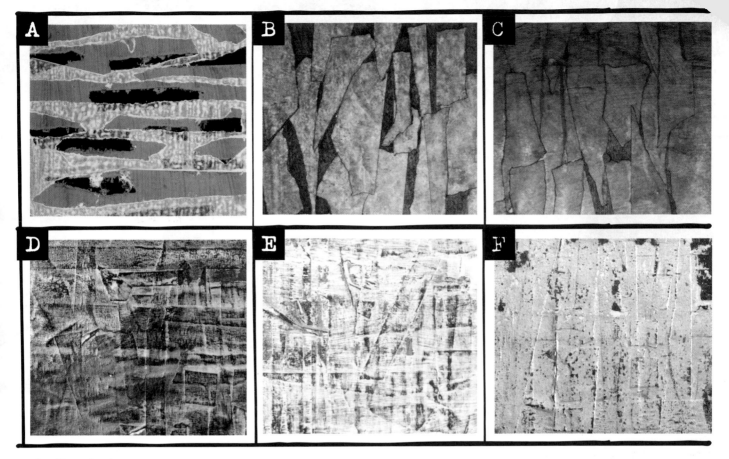

A. Resist: Apply the masking tape to the surface and paint over it. When the paint has dried, peel the tape off to reveal the surface. This looks especially interesting when you use multiple layers—just make sure the paint is dry before applying another layer of tape and paint. **B. Stain:** Apply paint full strength and rub off the excess paint. The surface and the tape take paint differently, adding interest to your art. **C. Glaze:** Add glazing medium to your acrylic and apply it to the taped surface; glazing and glazing gradients allow the beauty underneath to show through. **D. Layer color:** Let your imagination and paint go crazy with color combinations, like a dark color with an interference paint on top. **E. Dry brush:** Over a dry painted surface, use a dry paintbrush to apply a different color on top of the tape. The new color will catch the edges of the tape, enhancing the texture. **F. Metal leaf:** Apply metal leaf (see Metal Leaf on page 38); use a wadded-up piece of masking tape to rub off the excess metal leaf and reveal the texture underneath.

Crackle Paste

...e of our favorite pastes. It is a little finicky but well worth the time it takes to learn how to use it. The size of the crackle depends on how thickly you apply that the crackle paste. Make sure you work on a rigid surface; otherwise, the paste will flake off.

MATERIALS + TOOLS

crackle paste

palette knife

surface

stencils

water

acrylic paint

paintbrush

paper towel

SURFACES

panel

Plexiglas

ARCHIVAL QUALITY

Excellent

TIPS

If desired, you can tint the crackle paste with acrylic paint. The paste cannot be tinted more than 20 percent. When the paste is tinted, it will appear white if you sand the painted surface.

Try different brands and types of crackle paste for different looks.

1 Apply crackle paste to the surface with the palette knife, varying the thickness.

2 In a different area, apply crackle paste through a stencil. Let the paste dry overnight. Do not force the paste to dry, because the crackle develops during the drying process.

3 When dry, mist the crackle surface with water. Dilute the acrylic paint with water. Using a clean paintbrush, apply the diluted paint over the crackle paste. You will see the paint seep into the cracks.

4 Use a paper towel to blot the paint from the surface. Let the surface dry. You can now add diluted paint as desired to enhance the design.

VARIATIONS

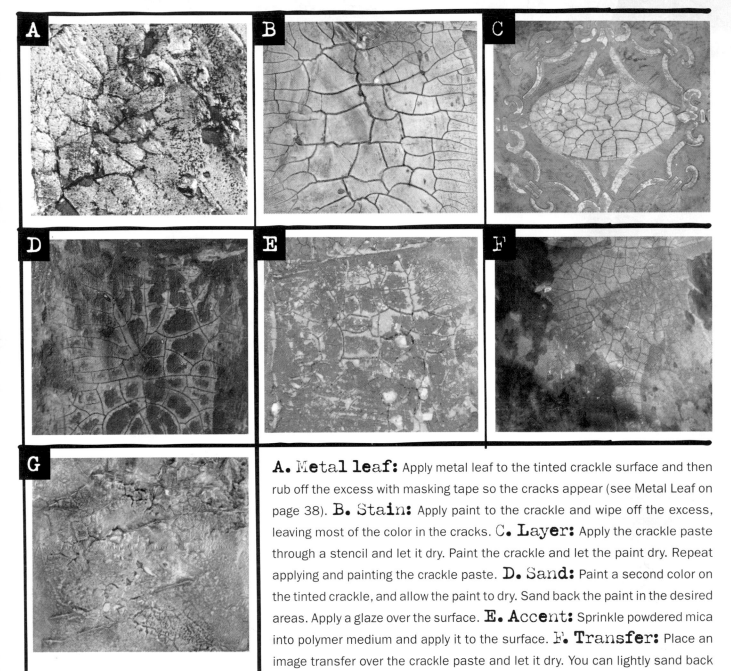

A. Metal leaf: Apply metal leaf to the tinted crackle surface and then rub off the excess with masking tape so the cracks appear (see Metal Leaf on page 38). **B. Stain:** Apply paint to the crackle and wipe off the excess, leaving most of the color in the cracks. **C. Layer:** Apply the crackle paste through a stencil and let it dry. Paint the crackle and let the paint dry. Repeat applying and painting the crackle paste. **D. Sand:** Paint a second color on the tinted crackle, and allow the paint to dry. Sand back the paint in the desired areas. Apply a glaze over the surface. **E. Accent:** Sprinkle powdered mica into polymer medium and apply it to the surface. **F. Transfer:** Place an image transfer over the crackle paste and let it dry. You can lightly sand back the image to regain the texture. **G. Drama:** Try bronze and black glazes over a crackle surface.

TROUBLESHOOTING

If your crackle flakes off, your surface may not be rigid enough. Repeat the technique using a sturdier surface.

Apply an acrylic polymer, like GAC 200, over the dried crackle surface to create more tooth and increase the potential to adhere items to the background.

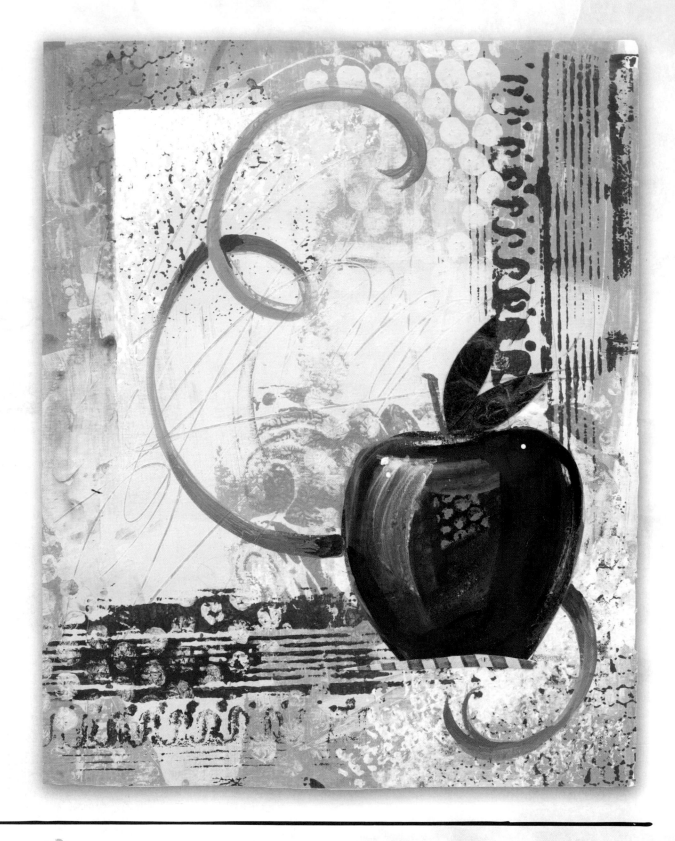

APPLE FOR EVE
Darlene Olivia McElroy

Main technique: Stamping (page 12)

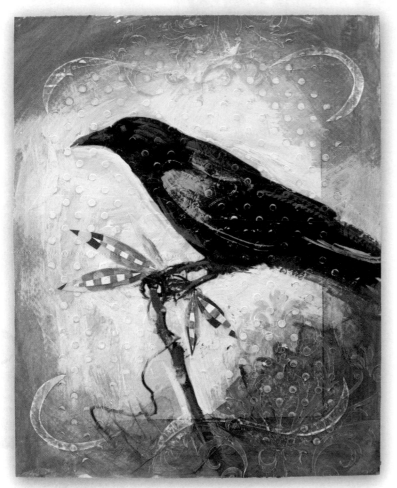

SEEKER
Darlene Olivia McElroy

Main technique: Stencil (page 14)

WAVE LENGTHS
Sandra Duran Wilson

Main technique: Aluminum Foil (page 16)

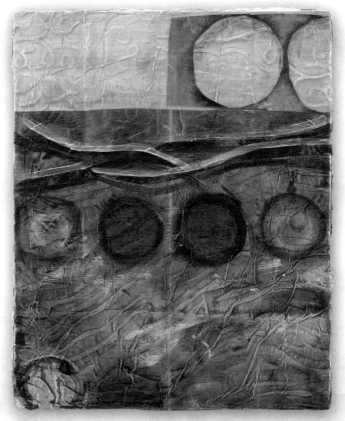

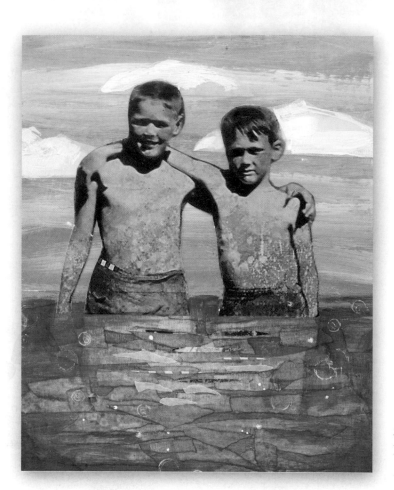

SUMMER DAYS
Darlene Olivia McElroy

Main technique: Masking Tape (page 18)

THE FINAL FRONTIER
Sandra Duran Wilson

Main technique:
Crackle Paste (page 20)

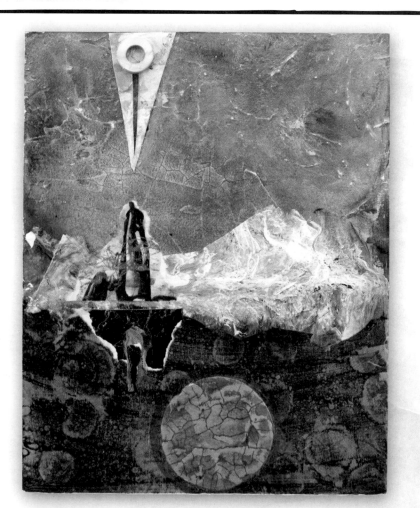

24

THE MISSING LINK
Sandra Duran Wilson

Main technique: Faux Encaustic (page 26)

Faux Encaustic

Encaustic is a technique of painting with wax that garners a beautiful surface with great depth; this technique achieves a similar effect using acrylics and gels. The key is in the layers: Add something to each layer to give the eye something to distinguish each layer.

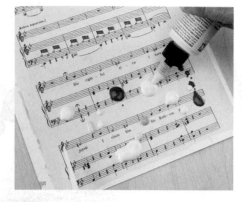

1 Determine which encaustic recipe you would like to use, and prepare it. Start with a base painting or collage on your surface. Apply the acrylic paint in drops onto the surface.

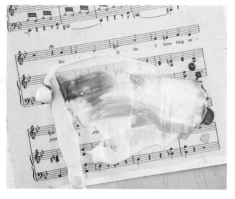

2 While the paint is still wet, apply the recipe. Using a palette knife, spread the recipe into the paint. Make some areas thicker than others. Allow the layer to dry. It may take overnight to dry completely.

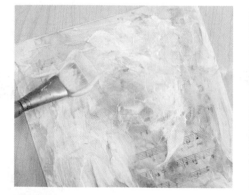

3 Repeat step 2 until you achieve the desired look. A paintbrush may be easier to use over the layers. Allow each layer to dry before adding the next.

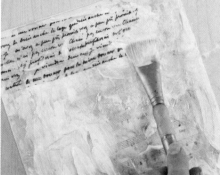

4 To embed objects or thin papers into the artwork, lay the item on the surface and use a paintbrush to apply the recipe of choice. Lightweight materials will use a thinner recipe, while heavier objects will need something thicker.

When you are satisfied, let the work cure for about a week.

MATERIALS + TOOLS

acrylic paint

surface

encaustic recipe

palette knife

paintbrushes

assorted gels and mediums

SURFACES

canvas

panel

paper

ARCHIVAL QUALITY

Excellent

TIPS

To get a satiny finish like wax, use a gloss mixture, let it cure and then spray with a satin varnish.

For a thick, waxy look, use at least five layers of a matte mixture.

For a smooth surface, mist each layer with alcohol to pop air bubbles.

If you pour thick layers and you don't want the medium to run over the edges, you will need to put masking tape around the edges of your painting surface. This will create a lip and prevent the medium from flowing over the edge.

TROUBLESHOOTING

If your surface is too opaque, you can bring back a little clarity by applying a layer of polymer medium gloss to the dried surface. Let it cure for several days before varnishing.

VARIATIONS

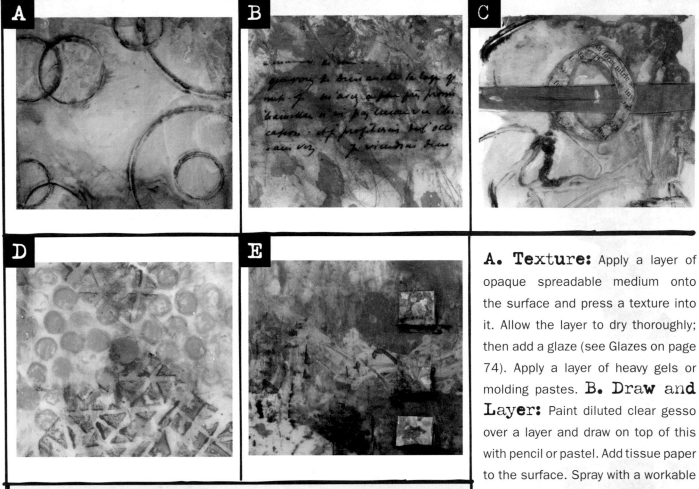

RECIPES

OPAQUE POURING MEDIUM: This is a pourable matte medium good for building a lot of layers. The finished surface will be opaque.

Dilute fluid matte medium with water about 20 percent. Stir to blend. (For a little more color, add a drop or two of Transparent Yellow or Nickel Azo Gold.) If you want some little air bubbles, shake before pouring. For a really smooth surface, stir gently, let sit, and then pour. When air bubbles arise, mist the surface with alcohol.

CLEAR POURING MEDIUM: This is a pourable clear medium. If you want to be able to see all the layers, use this recipe.

Mix soft gel gloss with 20 percent water or until it is a pourable consistency. Add one drop of Transparent Yellow or Nickel Azo Yellow and one drop interference blue.

OPAQUE SPREADABLE GEL: It dries to a waxlike surface.

Using Golden High solid gel matte, spread a thin layer over the surface. You can thin out the gel with a small amount of water to make it more spreadable. To make it more opaque, use Golden extra-heavy gel/molding paste; apply thinly or it will be too opaque.

A. Texture: Apply a layer of opaque spreadable medium onto the surface and press a texture into it. Allow the layer to dry thoroughly; then add a glaze (see Glazes on page 74). Apply a layer of heavy gels or molding pastes. **B. Draw and Layer:** Paint diluted clear gesso over a layer and draw on top of this with pencil or pastel. Add tissue paper to the surface. Spray with a workable fixative and then put a layer of clear pourable medium on top. Finish the piece with a satin varnish spray. **C. Pour:** Paint onto your work, and while the paint is still wet, pour a layer of the chosen recipe on top. **D. Stamp:** Layer opaque spreadable medium, let dry, stamp a layer and finish with another layer of high solid gel matte. **E. Collage:** Create a background and apply a thick layer of soft gel gloss with a knife to create texture. Glaze; let dry, add another opaque pourable medium, collage, another layer of opaque pourable medium, glaze and spray with satin varnish.

27

Gels

Gels are the key to manipulating acrylic paint. By adding different gels, you can make the paint thick and stiff to hold peaks or make your acrylics behave and blend like oil. Soft gel gloss is a main go-to medium. When mixed with paint, it extends drying time and can work as an isolation layer, as glue for collage or as a final finish. Matte mediums contain matting agents, which can create an opaque layer or a tooth on which to draw. There are many types of gels, both gloss and matte: soft, regular, heavy, high solid, self-leveling and extra heavy.

MATERIALS + TOOLS

assorted gels, both matte and gloss: soft gel gloss, heavy gel matte, high solid gel gloss, heavy gels or molding, pastes and polymer medium

surface

palette knife

acrylic paint

paintbrush

mark-making tools

sandpaper (optional)

SURFACES

canvas

panel

watercolor paper

ARCHIVAL QUALITY

Excellent

TIPS

Gloss gels dry very clear, and matte gels dry cloudy. You can always change the sheen of the finished piece from gloss to matte with a final coat of varnish. I always opt for the clear, especially for building multiple layers.

Matte gels are more opaque and will mute colors.

Gloss dries clear and shows the underlying layers.

Apply gels with a spatula or palette knife for a smooth surface; use a paintbrush for more texture.

Gel mediums are great glues. Choose the proper weight gel to match the weight of the object to be glued. For thin papers and light objects, the soft gel gloss is good. For heavier papers or objects, use regular gel. To glue thicker papers and objects, use the heavy gel. For bulky items like a button or metal, an epoxy will work best.

1 Apply a thin layer of heavy gel or molding paste with a palette knife. Use your knife to drag gels, both matte and gloss, across the surface. Let dry.

2 Mix paint into assorted gels and drag a thin layer across the surface with a paintbrush. You can scratch back with tools to reveal underlying layers. Let dry, sand slightly if you desire and then glaze or paint.

TROUBLESHOOTING

If you apply a matte gel and it is too opaque, go over it with a polymer medium gloss to bring back some of the clarity. The gloss will not bring it back completely, however.

VARIATIONS

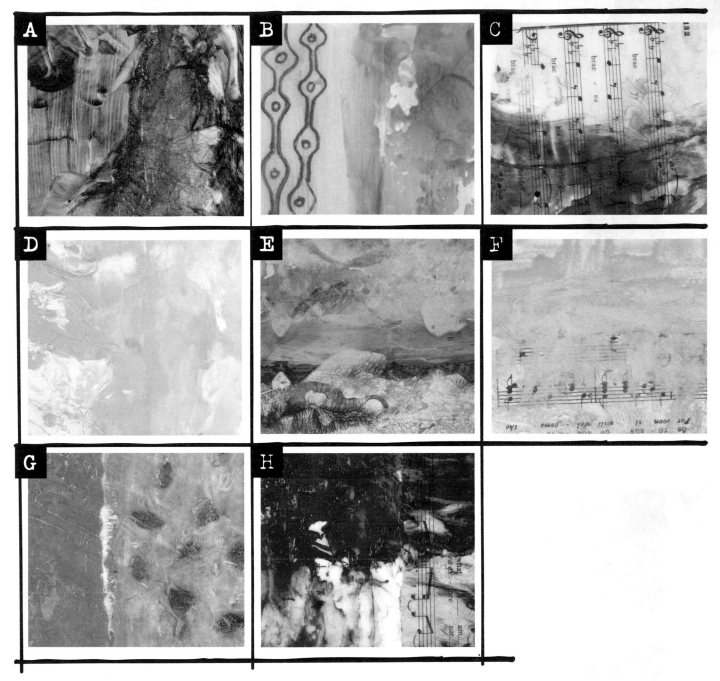

A. Glue: Use soft gel gloss, mixed with acrylic paints, as a glue to embed paper. **B. Draw:** On top of a layer of soft gel matte, mixed with light green, draw a design with pencil. **C. Collage:** This variation features high solid gel matte, mixed with blue paint, over a collage background. **D. Texture:** Using a palette knife, apply regular gel gloss, mixed with yellow, to add texture. The teal glaze complements the background. **E. Color:** Mix paints into regular gel matte, and apply color on top. **F. Layer:** Over a collage background, spread a layer of heavy gel matte and let dry. Paint a thin layer of teal over an area and let it dry. Paint an area with a combination of yellow paint and matte gel. **G. Transparent:** Use heavy gel gloss mixed with paint as glue for foam. **H. Opaque:** A high solid gel, mixed with paint and put over a collage, is not as clear as gloss gels.

| # Gesso

Gesso is not just a primer, it can be the start of a great painting.

MATERIALS + TOOLS

gesso (white and black)
surface
palette knife
rubber brush or mark-making tools like twigs, skewers or corrugated cardboard
paintbrush

SURFACES

canvas
panel
watercolor paper

ARCHIVAL QUALITY

Excellent

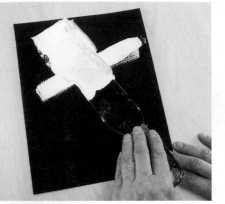

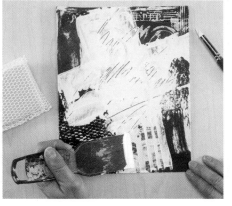

1 Apply the gesso to the surface using a palette knife or paintbrush. The paintbrush gives you a fabriclike texture, while a palette knife gives you a smoother texture. In this case, we are applying white gesso over dry black gesso.

2 Using a rubber brush and mark-making tools, add texture to the wet gesso. When you are satisfied with the design, let the gesso dry.

TIPS

For a supersmooth gesso, apply gesso and let it dry. Then spritz with alcohol and sand with a fine-grit sandpaper.

TROUBLESHOOTING

If you don't like your design, reapply the gesso.
 If the gesso dries before you can apply textures, you can add more gesso and continue mark making or pressing textures.

VARIATIONS

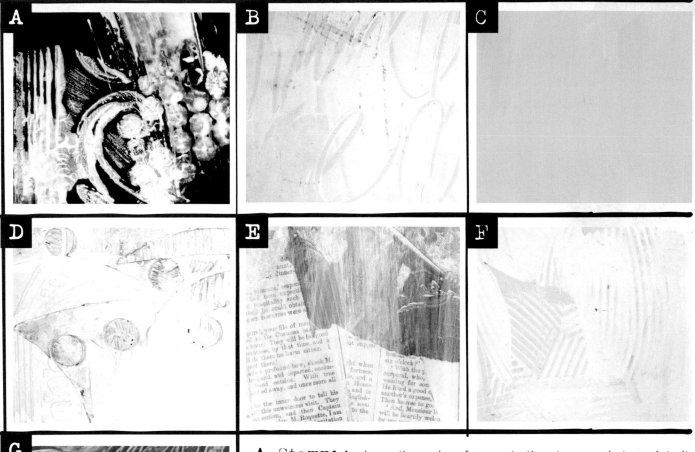

A. Stamp: Apply another color of gesso to the stamp and stamp into it.
B. Scribe: Scribe into the gesso, while it's wet, with rubber brushes, twigs and mark-making tools (see Scribing on page 122). **C. Tint:** Tint using acrylic paint. (For dark colors, it is better to buy them already made.)
D. Embed: Glue papers and objects to the surface prior to applying the gesso to the surface. **E. Wash:** Apply a gesso wash over a collage to unify the surface. **F. Texture:** Apply gesso with a textured element, like a corrugated coffee-cup sleeve. **G. Stain:** Apply paint to a dry gesso surface and then rub off the excess paint.

ADDITIVE | Fiber Paste

Fiber paste is a wonderful medium to play with! You can print on it, mold it, rust it, cut it and stencil with it—it takes paint well and so much more.

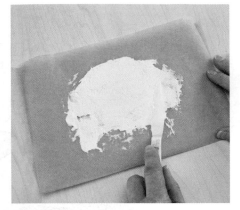 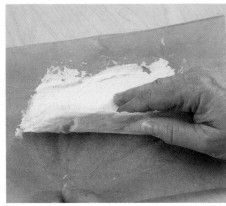

1 Using the palette knife, spread the fiber paste onto your surface of choice, whether it is your working surface or plastic wrap or parchment paper for a skin (see Skins on page 46). While the fiber paste is still wet, add texture if desired. Let the fiber paste dry thoroughly.

2 If making a skin, as shown, you can lift it from the plastic wrap or parchment.

MATERIALS + TOOLS

palette knife
fiber paste
surface

SURFACES

canvas
panel
plastic wrap or parchment paper
watercolor paper

ARCHIVAL QUALITY

Very good

TIPS

If you spread fiber paste on glass, parchment or polypropylene, you can lift it off and cut it into shapes when dry.

If you print an image onto the dry fiber paste with an ink-jet printer, you can add water to smear the paint like watercolor. If you want the image to stay put, spray a workable spray fixative onto the image and allow it to dry.

TROUBLESHOOTING

Allow the fiber paste to dry thoroughly before painting because it will be mushy until dry.

If you are printing onto the fiber paste, a digital ground (see Drawing Grounds on page 37) ensures a crisper image.

VARIATIONS

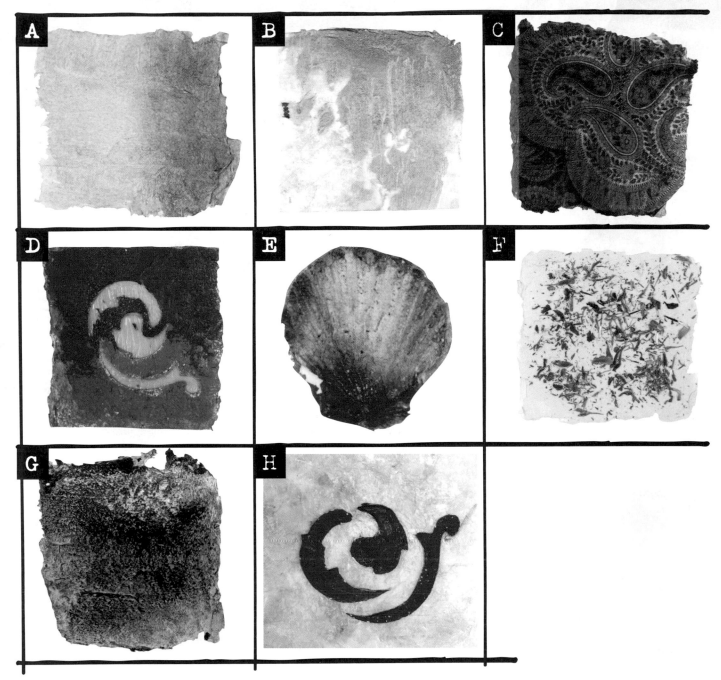

A. Play: Paint, rust, patina or add pastels. **B. Mix:** Add to an unusual surface like mica. **C. Print:** Attach a thin layer of fiber paste to a carrier paper and print an image onto it using an ink-jet printer. **D. Cut:** Cut the fiber paste into shapes; or cut a shape into the fiber paste and lay tinted gel in the hole. **E. Mold:** Use the fiber paste in a rubber mold. **F. Embed:** Sprinkle dried flowers or powder mica, or lay thread in the fiber paste while it is still wet. **G. Tint:** Mix color into the fiber paste before beginning the technique. **H. Stencil:** Add surface interest by applying it to the surface through a stencil. Paste can be tinted first or painted after the stenciled image dries.

Making Your Own Specialty Gels

There are many specialty gels you can buy—pumice gel, glass-bead gel, fiber paste and mica chips, just to name a few—but you can also make your own by adding elements to gels, gesso, paste or mediums. Different grits of sand, sawdust, broken shells, even kitty litter mixed with a binding agent will create a texture. These techniques can be fun to play with, but some are not intended for fine art projects.

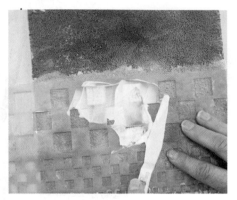

1 Paint the surface as desired. Apply a layer of regular gel through a stencil using a palette knife. Remove the stencil and clean it before the gel dries.

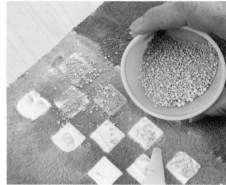

2 Sprinkle the kitty litter over the wet gel.

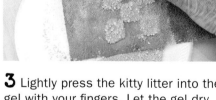

3 Lightly press the kitty litter into the gel with your fingers. Let the gel dry. Shake off excess kitty litter.

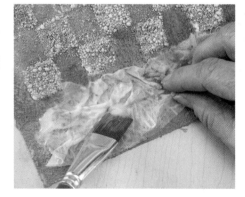

4 Apply polymer medium to the surface. Press the rice paper onto the polymer medium. Crumple up the rice paper as you apply it to the surface to create texture. Use a paintbrush dipped in polymer medium to coat the top of the rice paper and adhere it to the surface.

MATERIALS + TOOLS

paintbrush

acrylic paint

surface

assorted gels: regular gel, polymer medium and heavy gel

palette knife

stencils

kitty litter

rice paper

foam stamp

sand

acrylic spray

craft glue

SURFACES

canvas

panel

watercolor paper

ARCHIVAL QUALITY

Wood pulps and food products like coffee have high tannins and acids, and are not archival.

TIPS

Never mix more than a 60-40 mix. The binder has to be in the majority.

Experiment with different mediums. Remember, most food and plant materials are not archival.

Not all kitty litter is the same, so you may get different results with each kind.

 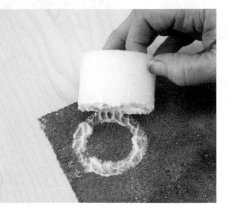 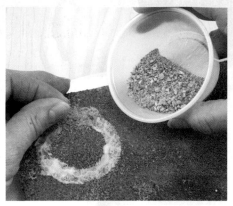

5 Using a palette knife, apply regular or heavy gel to a foam stamp.

6 Press the gel onto the surface.

7 Sprinkle sand on top of the gel.

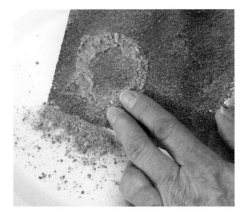 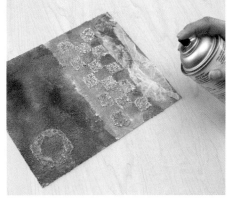 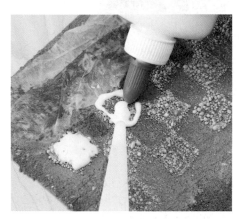

8 Gently tap down the sand with your fingers. Allow the gel to dry. Shake and brush off the excess sand.

9 Make sure all the gels on the surface are dry. Apply the acrylic spray to the sand element to help seal it.

10 To seal the kitty litter, pour the craft glue around the edges of the kitty-litter shape. Use the palette knife to spread the glue toward the center of each shape. Allow the glue to dry thoroughly.

You may now continue the artwork as desired.

TROUBLESHOOTING

If your texture doesn't come out as you like, scrape it off and start over.

When adding the craft glue to the kitty litter, it helps to outline the shape and then gently spread the glue inward. Try not to press too hard with the glue; otherwise, it will lift the kitty litter off the surface.

VARIATIONS

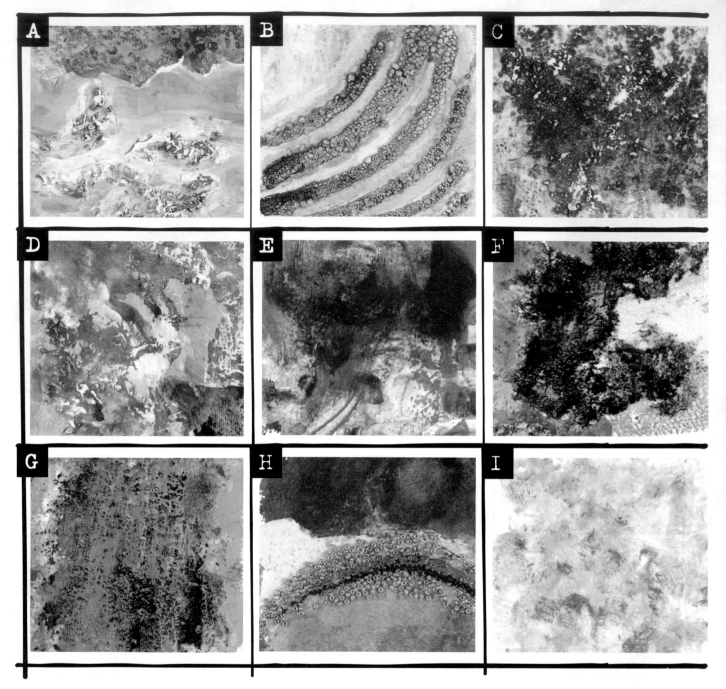

A. Grainy: Coarse sawdust with gesso. **B. Deep Texture:** Kitty litter sprinkled on top of matte medium. **C. Gritty:** Coarse sand with soft gel gloss. **D. Smooth:** Fine sawdust with water and matte medium. **E. Dark:** Carborundum grit with polymer medium. **F. Caffeinated:** Coffee grounds with heavy gel. **G. Herbal:** Tea—both leaves and instant—with soft gel. **H. Wild:** Glass beads with regular gel. **I. Soft:** Shredded paper with polymer medium.

ADDITIVE | Drawing Grounds

Do you have a slick surface or an uneven surface that has glossy and matte elements you want to draw or write on? Adding a thin layer of a ground adds tooth to the surface and allows you to do thin washes or draw with pastels, colored pencils or graphite.

MATERIALS + TOOLS

paintbrush

grounds: clear gesso, absorbent ground, pastel ground

surface

acrylic paint

pastels: soft or oil

colored pencils

SURFACES

canvas

panel

watercolor paper

ARCHIVAL QUALITY

Great

TIPS

Lay down ground thinly and wipe off excess to avoid a white, cloudy look.

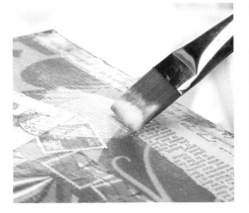

1 Using the paintbrush, apply a thin layer of ground to the surface and wipe off any extra. Allow the ground to dry.

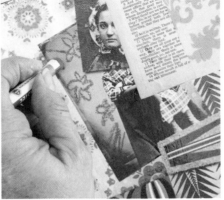

2 Paint or draw on the surface using the acrylic paints, pastels or colored pencils.

TROUBLESHOOTING

If your surface is cloudy, you added too much ground. If you follow the tip, you should be OK.

VARIATIONS

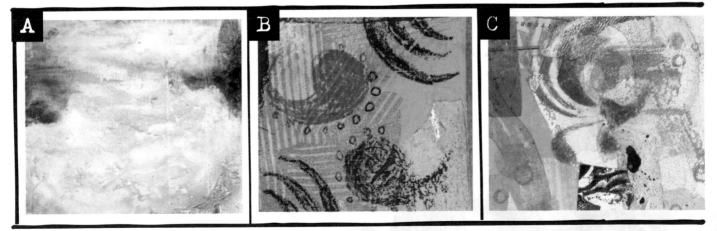

A. Wash: Lay down thin washes of color on ground. **B. Draw:** Use graphite, colored pencils or pastels to draw on the surface. **C. Combine:** Draw and paint on a collaged surface.

ADDITIVE | Metal Leaf

Here's a way to add bling to your art in an unconventional way. Though you can apply the metallic leaf in the traditional manner, I find it more fun to go for the unexpected.

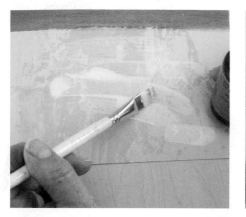

1 If desired, paint the surface and allow the paint to dry. Using a clean paintbrush, apply a thin layer of the adhesive to the surface. Continue to step 2 when the size is tacky, not wet. It will be clear, not cloudy.

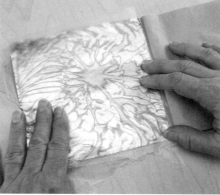

2 Place the wax paper over the metal leaf. Rub it with your hand to create friction. Lift up the wax paper, and the metal leaf should come with it.

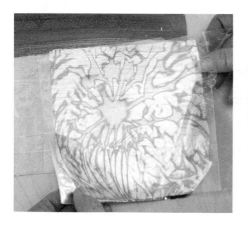

3 Apply the metal-leaf sheet to the tacky surface, smoothing the sheet of wax paper with your hand. Lift off the wax paper.

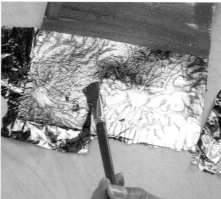

4 Repeat steps 2 and 3 until the desired areas of the surface are covered. (The semitransparency of the wax paper allows you to line up the metal leaf better.) Using a clean, dry paintbrush, wipe off excess leaf and then seal with metallic leaf sealer.

TROUBLESHOOTING

Too much spray glue will cause a puddle that gets gooey, not tacky. Make sure you cover the areas of your surface where you don't want glue.

MATERIALS + TOOLS

paintbrush

surface

acrylic paint

adhesive such as gold-leaf adhesive size, rubber cement, glue stick or spray glue

wax paper

metal leaf

disposable stencil

masking tape

SURFACES

canvas

metal

panel

paper

Plexiglas

objects

ARCHIVAL QUALITY

Rubber cement and glue sticks are less archival than other adhesives.

TIPS

Wax paper helps tremendously with metallic leaf. Eventually, it loses its ability to adhere: get a new piece of wax paper.

Use a metallic leaf sealer to keep the leaf from tarnishing.

Joss paper is a beautiful alternative to metal leaf: You can burnish down the joss paper or scribe the back side to get marks.

Mica powders are also fun to experiment with. Brush them onto the tacky glue and allow it to dry. Remove the excess with a clean, dry paintbrush or a damp cloth.

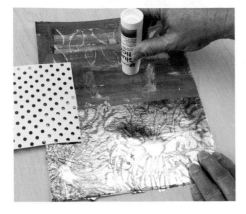 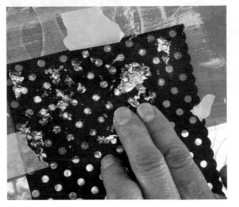 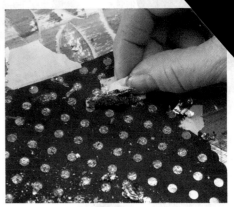

5 Rub a glue stick over the surface. (We are showing you the nontoxic way, but you can also use spray glue through a disposable stencil to get a tacky pattern.)

6 Attach the stencil with the masking tape to secure the stencil to the background. Repeat steps 1–4 to move a sheet of metal leaf onto the stencil. Use your fingers to rub the metal leaf into the openings of the stencil.

7 Use a wadded-up piece of masking tape to remove the excess metal leaf. Remove the stencil and continue creating.

VARIATIONS

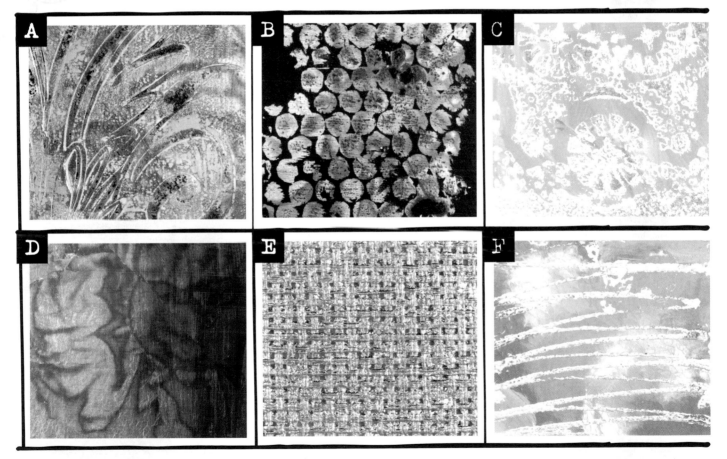

A. Rub Back: After applying metal leaf to the textured surface, rub it off with masking tape. **B. Stamp:** Apply glue to the surface using a stamp. Apply the metal leaf and rub off the excess with masking tape. The leaf sticks only where the glue was laid down. **C. Spray:** Apply spray glue through shapes with holes (doilies, shade cloth, etc.). Apply the metal leaf to the surface and rub off the excess with masking tape. The leaf sticks only where the glue was laid down. **D. Glaze:** Add glazing medium to your paint, and apply the glaze over the metal leaf to alter the appearance of the metal leaf. **E. Surfaces:** Try this technique on textured surfaces like burlap, lace and various objects. **F. Draw/Write:** Put metallic-leaf size in a squeeze bottle with a tip and write on the surface. Apply the leaf as instructed, and rub off the excess.

39

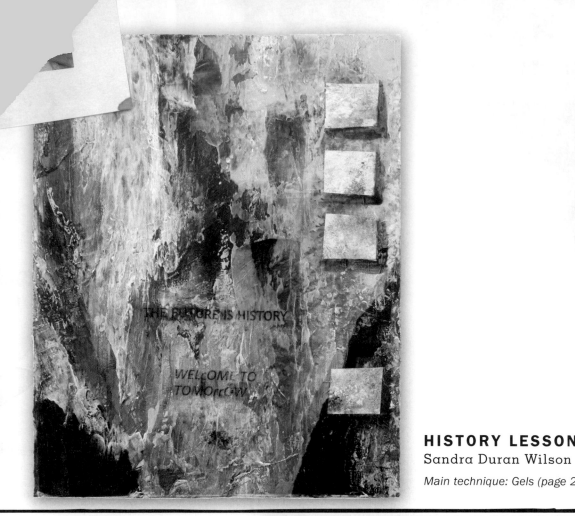

HISTORY LESSON
Sandra Duran Wilson

Main technique: Gels (page 28)

SIRENA
Darlene Olivia McElroy

Main technique: Gesso (page 30)

40

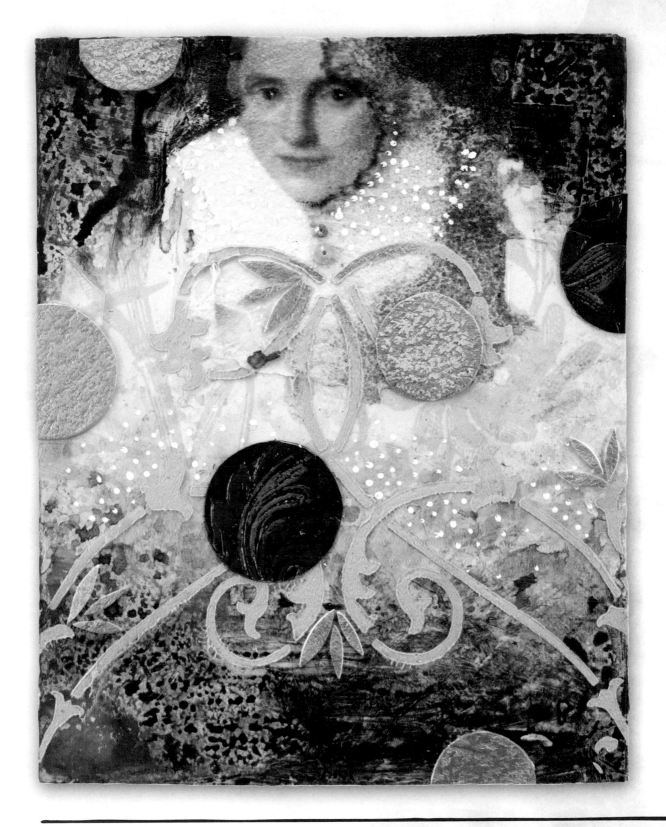

DREAM SHAPE
Darlene Olivia McElroy

Main technique: Fiber Paste (page 32)

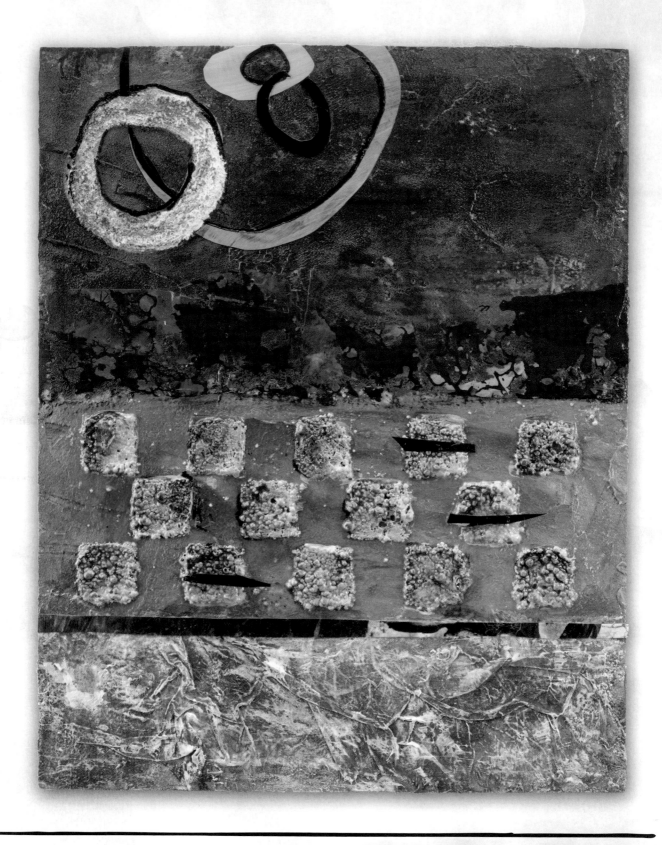

THE GAME OF LIFE
Sandra Duran Wilson

Main technique: Making Your Own Specialty Gels (page 34)

DREAMS COME TRUE
Darlene Olivia McElroy

Main technique: Drawing Grounds (page 37)

SERIOUS MAN
Darlene Olivia McElroy

Main technique: Metal Leaf (page 38)

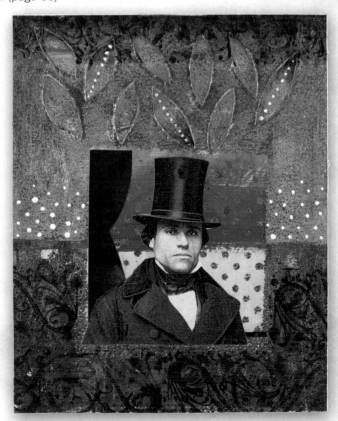

43

ADDITIVE | Pastes

Molding or modeling pastes come in many varieties: light, hard, flexible, coarse and regular (crackle and fiber are covered separately, on pages 20 and 32). Pastes are opaque to varying degrees. You can apply the paste as a texture background and paint over it, or you can mix the paint into the paste; pastes also take stains and glazes beautifully. They are best applied with a palette knife or spatula.

MATERIALS + TOOLS

palette knife

pastes: hard, flexible and light molding

acrylic paint

surface

stencils

paper towel

paintbrush

glazing medium

SURFACES

Depending on the paste, choose the appropriate surface:

canvas

panel

paper

Plexiglas

ARCHIVAL QUALITY

Excellent

TIPS

Flexible molding paste and light molding paste are most suited for canvas, and hard molding paste works best on a rigid support because of the weight. If you are not covering large areas, hard paste will be fine on canvas or paper.

Try these items as mark-making tools: toothpicks, chopsticks, a plastic fork, color shapers, a palette knife, plastic lids, an end of pencil or paintbrush, a graining tool, foam. See what else you have to use.

If you want to remove some color from dried layers of paste that have been glazed, apply untinted glazing medium to the chosen area and rub the area with a damp cloth. The glazing medium acts as an eraser.

1 Apply a base coat of light molding paste mixed with an acrylic paint (I'm using cobalt) on one side of the surface and flexible molding paste mixed with acrylic paint (I'm using magenta) on the other side.

2 Apply the hard and light molding pastes through stencils.

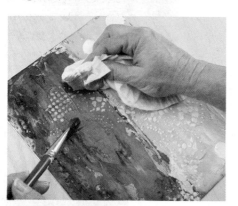

3 Mix the glazing medium with the paints of your choice. (I am putting an orange glaze over the magenta side and a green glaze over the cobalt side.) Use the paper towel to wipe the glaze off if desired.

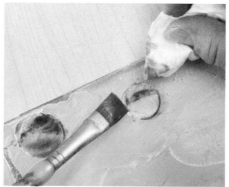

4 Paint a glaze or a thin layer of paint over the circles. Let it dry slightly and then wipe off the surface, letting the color stay in the crevices. Apply more layers of molding paste, colors and glazes as desired.

44 TROUBLESHOOTING

Pastes shrink about one-third upon drying. Apply a thick enough layer to account for the shrinkage.

VARIATIONS

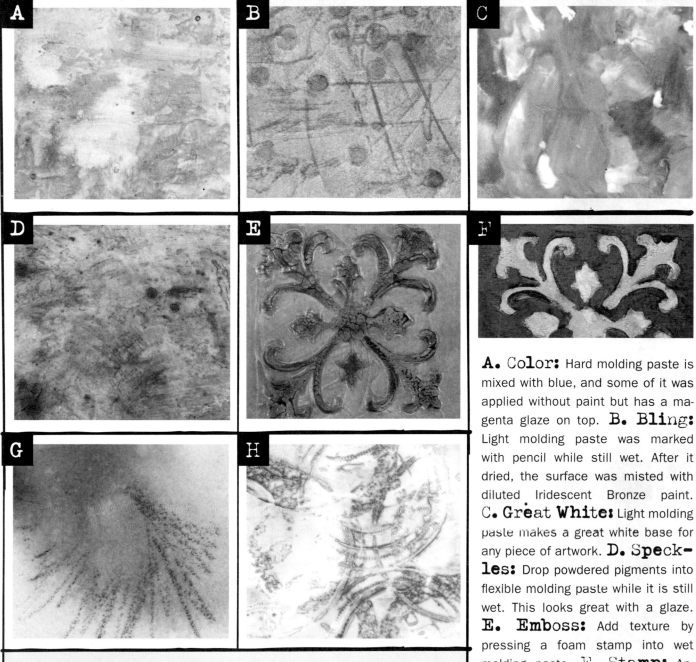

A. Color: Hard molding paste is mixed with blue, and some of it was applied without paint but has a magenta glaze on top. **B. Bling:** Light molding paste was marked with pencil while still wet. After it dried, the surface was misted with diluted Iridescent Bronze paint. **C. Great White:** Light molding paste makes a great white base for any piece of artwork. **D. Speckles:** Drop powdered pigments into flexible molding paste while it is still wet. This looks great with a glaze. **E. Emboss:** Add texture by pressing a foam stamp into wet molding paste. **F. Stamp:** Apply light molding paste to a stamp and apply the stamp to the surface. **G. Draw:** Coarse molding paste makes a great surface, similar to watercolor paper, that is lovely to draw on. **H. Play:** Mix a variety of pastes with objects pressed into them. A blue glaze was added after the pastes had dried.

PASTES HAVE DIFFERENT PROPERTIES

Light molding paste is airy and porous. It creates a beautiful texture that absorbs glazes and is easy to carve into. It is great for covering large areas because it doesn't add much weight. Light molding paste is an excellent mixing white. It won't dull your bright colors.

Regular molding paste is heavier and not as absorbent. It makes great textures when applied with a knife and is beautiful with glazes applied over it. It is slightly translucent if applied thinly. Flexible molding paste has similar qualities as regular, but it is best for use on canvas.

Coarse molding paste has some qualities of light molding paste, but it has a gritty texture. It absorbs like paper if washes are applied. Hard molding paste is heavy and very opaque. It is the paste to use for sanding and carving. It won't get gummy.

ADDITIVE | Skins

A skin is a sheet of paint or gel. The variations for this technique yield so many different-looking results, people will be amazed at what you can do with just one medium.

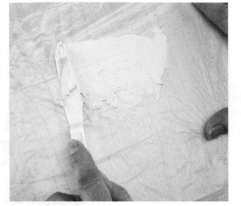

1 On a clean glass, plastic wrap or polypropylene surface, pour and spread out the paint, gel or fiber paste. If you want to embed items into the medium, now is the time to do it. Let the medium dry thoroughly; depending on the thickness, this may take more than a day.

2 Gently peel the skin off the surface. If it's too thin, you may have to add another coat.

MATERIALS + TOOLS

palette knife

paint, gel or fiber paste

glass, plastic wrap or polypropylene (a plastic painter's tarp works well)

objects like buttons, beads or florist wire (optional)

SURFACES

Skins can be adhered to the following surfaces:

canvas

metal

panel

paper

Plexiglas

wood

ARCHIVAL QUALITY

Excellent

TIPS

Craft paints typically have a thinner binder, so you might need to add a layer of self-leveling gel if you use craft paints as your medium.

For the thinnest skins, try using a polypropylene cutting board, such as those typically found in the kitchen.

TROUBLESHOOTING

If the skin is not thick enough, it will likely tear when you lift it from the glass, plastic wrap or polypropylene. Adding a layer of soft gel or clear leveling gel will provide added thickness. Let it dry thoroughly before removing the skin.

VARIATIONS

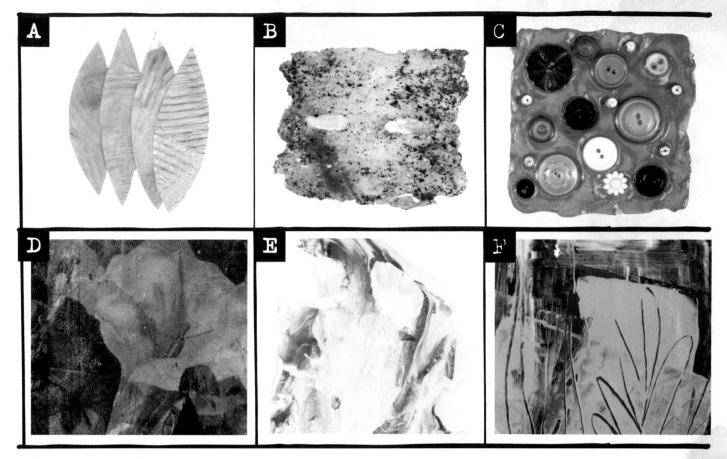

A. **Cut:** You can cut the skins into shapes you can glue onto your art. **B.** **Rust:** Apply soft gel to a rusty surface. Allow the gel to dry thoroughly, and peel it from the surface. The rust will stick to the gel. **C.** **Embed:** Embed buttons, dirt, beads, sticks and more into the gel or paint and let it dry. This is an easy way to add dimension to your art. **D.** **Print:** Create the skin (the thinner, the better), and apply a digital ground to it. After the ground is completely dry, you can print on it using an ink-jet printer. (This technique can be found in *Image Transfer Workshop.*) **E.** **Pour:** Pour paint onto the surface and drop different colors of paint on it. Use a toothpick to draw a design or create swirls. **F.** **Paint:** Paint an image on the surface as though you were painting on canvas. Apply a layer of gel to it if the painting is thin.

Spray Webbing

Krylon makes webbing spray in gold, black and silver. It creates a marblelike textured finish.

MATERIALS + TOOLS

paintbrush

acrylic paint

surface

Krylon Webbing Spray

paper towels or newspaper

SURFACES

canvas or fabric

metal

Mylar

panel

papers

Plexiglas

ARCHIVAL QUALITY

Good

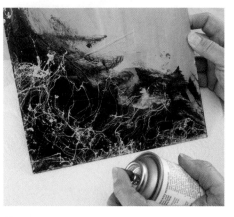

1 Paint the surface using colors that will allow the web to show up. For demonstration purposes, we're using a high-contrast color.

2 Ideally, do this step outside or in a well-ventilated area. Cover your work surface with paper towels or newspapers. Spray the webbing spray, according to the manufacturer's instructions, onto the surface. Allow the webbing to dry before you finish the artwork.

TIPS

Spray outside. It works great if you spray the webbing spray up in the air and catch it on your surface as it floats down. Or put your surface on the ground and spray from above.

If you do not want to cover the entire surface with webbing, you can block off areas with newsprint to keep it from being sprayed.

TROUBLESHOOTING

If your web is clumping instead of giving you a web effect, you're likely holding the can too close to the surface. Hold the can farther away as you spray.

VARIATIONS

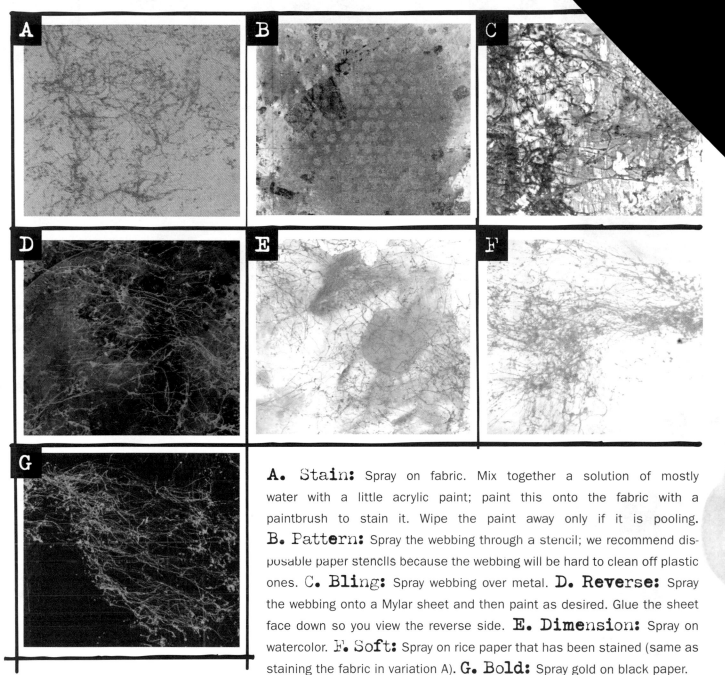

A. Stain: Spray on fabric. Mix together a solution of mostly water with a little acrylic paint; paint this onto the fabric with a paintbrush to stain it. Wipe the paint away only if it is pooling. **B. Pattern:** Spray the webbing through a stencil; we recommend disposable paper stencils because the webbing will be hard to clean off plastic ones. **C. Bling:** Spray webbing over metal. **D. Reverse:** Spray the webbing onto a Mylar sheet and then paint as desired. Glue the sheet face down so you view the reverse side. **E. Dimension:** Spray on watercolor. **F. Soft:** Spray on rice paper that has been stained (same as staining the fabric in variation A). **G. Bold:** Spray gold on black paper.

...ed Paper

...ting a grunge look. It gives the
...all that have been pulled off

MATERIALS + TOOLS

paintbrush

acrylic paint

surface

palette knife

soft gel

ink-jet image or newspaper page

burnisher, bone folder or spoon

SURFACES

canvas

panel

watercolor paper

ARCHIVAL QUALITY

Good. Ink-jet images or newsprint will need a final UV varnish to protect against fading.

TIPS

Try combining this technique with the Petroleum Jelly technique (page 90) for more depth.

The time for leaving the paper on may vary depending on the season or weather conditions. Hot and dry climates will take less time than humid areas.

Try painting or stamping on top just for fun.

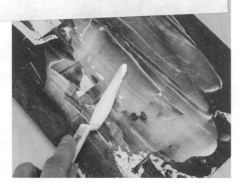

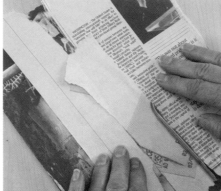

1 If desired, paint the surface. With the paintbrush or palette knife, apply a light coat of the soft gel medium to the surface.

2 Lay an ink-jet image or a newspaper page down and burnish. Hum the theme song to *Jeopardy* twice (it's about thirty seconds).

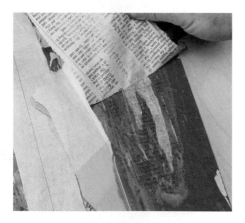

3 Lift the paper off; the ink of the text or image will stick to the surface, as will some of the paper. If you want more to adhere, leave it on slightly longer. If you want to get rid of more of the paper, wet your finger and rub lightly. Let the surface dry before you continue with your artwork.

VARIATIONS

A

A. Layering: Repeat all steps with different images as many times as desired.

TROUBLESHOOTING

If the gel is too thick, the paper will rub off when you burnish.

If the gel is too thin, the paper won't stick, because the gel dries too quickly.

Any images you may want to use will be in reverse. Flip the image in the computer, or just make the reversal part of the design.

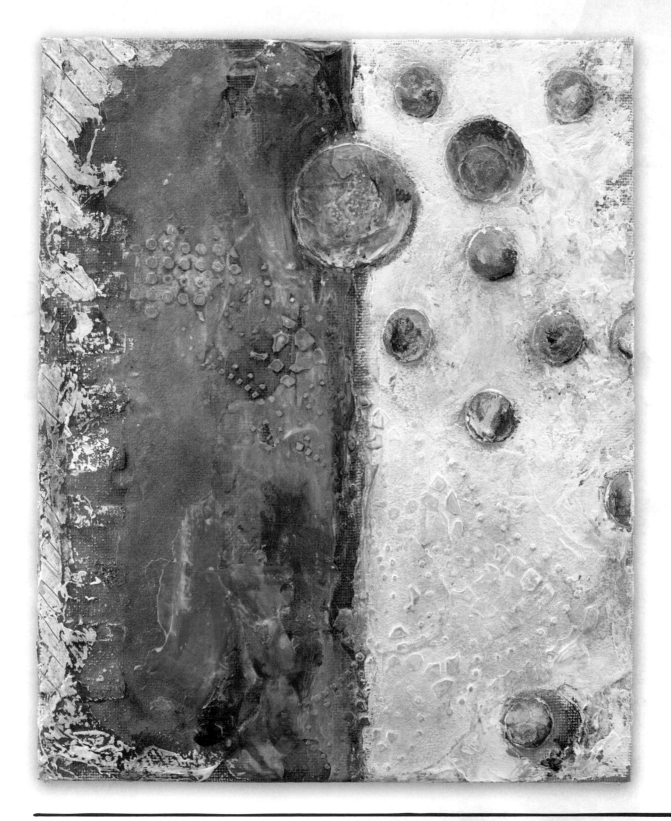

THE JOY OF FLIGHT
Sandra Duran Wilson

Main technique: Pastes (page 44)

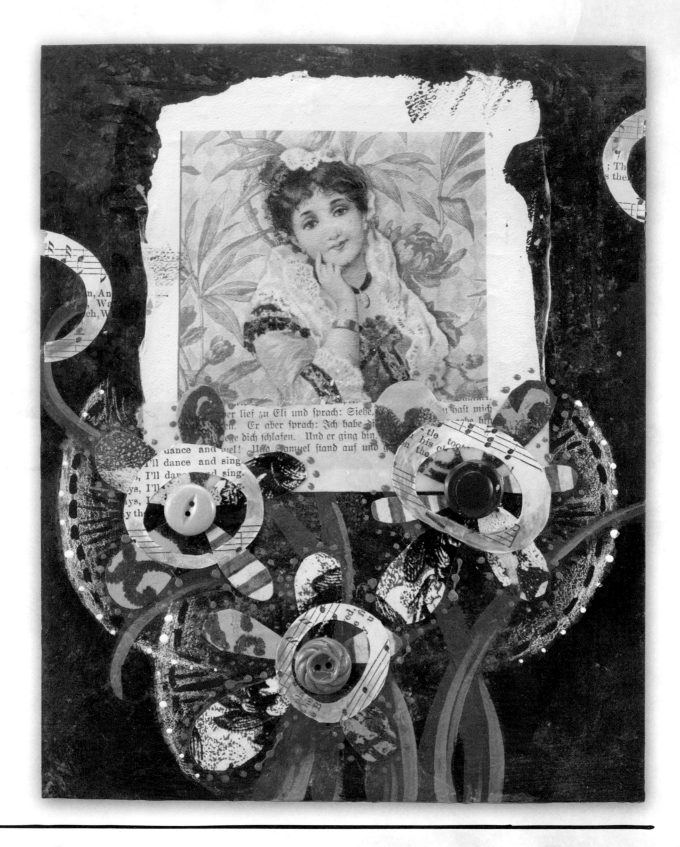

OH, HAPPY DAY
Darlene Olivia McElroy

Main technique: Skins (page 46)

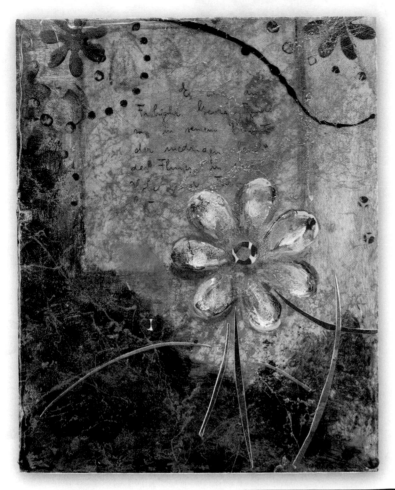

NATURE'S WEB
Sandra Duran Wilson

Main technique: Spray Webbing (page 48)

MEMORIES
Darlene Olivia McElroy

Main technique: Pulled Paper (page 50)

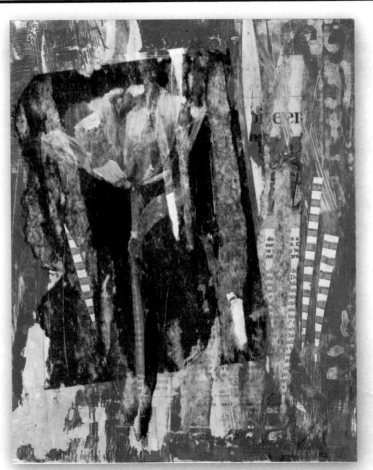

Gel String

Tar Gel is a unique product made by Golden; Liquitex makes a similar product called String Gel. Both have the unique property of being stringlike. You may mix them with paints or use as is for a clear resist.

MATERIALS + TOOLS

clear gel string medium
small plastic containers with lids
acrylic paint
paintbrush
surface
palette knife

SURFACES

canvas
panel
Plexiglas
watercolor paper

ARCHIVAL QUALITY

Excellent

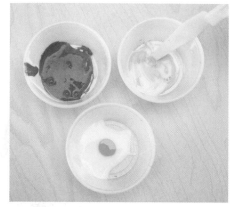

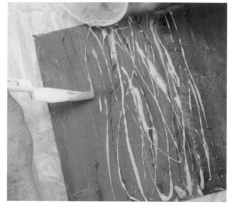

1 Pour 1 oz. of the gel string medium into the small plastic containers. Mix 1–3 drops of fluid acrylic paint into the cups, stirring well to fully incorporate the color. Cover the cups and let the gel string medium sit for a couple hours.

2 Paint the surface as desired and allow the paint to dry. Without remixing the gel string, dip the palette knife into the desired color of gel string. Hold the cup close to the surface, and slowly drag the palette knife just above the surface; the gel string will run off the knife in a thin string. Continue to layer colors of choice. Let all layers dry completely before continuing the artwork.

TIPS

Hold the cup and knife close over the surface as you dribble. Your strings will vary in width depending on how fast you move the knife across the surface.

Clay shapers are fun tools to help move the gel string medium around.

When using wax paper as your surface, the dry gel string medium can be pulled off and hung like a sculpture.

The resist technique is great for creating a batiklike surface. Clear gel string medium, when dry, will act as a resist. When it is painted over, it won't hold color.

TROUBLESHOOTING

Do not remix the gel after you have added color, because it will not "pull" like strings. If you forget and remix, just let it sit for a couple hours, and it will regain its unique properties.

When you are using multiple colored gels in your artwork, adding separate colors while both are wet will give you some color mixing. Do not mix too many colors while wet, or you will end up with mud. If you want crisp lines, let each color dry before adding the next color.

Sponge Rollers and Art Foam

Cut into sponge rollers or sponge brushes or put rubber bands around them. Carve into art foam or glue shapes on it. This technique can be combined with already-painted surfaces—try it with other surface treatments for surprising results.

MATERIALS + TOOLS

foam brushes

foam rollers

art foam

scissors

rubber bands

acrylic paint

surface

SURFACES

canvas

metal

panel

paper

Plexiglas

ARCHIVAL QUALITY

Excellent

TIPS

You get a different look depending on the wetness of the paint.

1 Assemble the various foam brushes and rollers, art foam and scissors. Cut the art foam and foam brushes as desired. Wrap rubber bands around a foam roller.

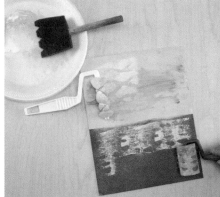

2 Roll the various foam brushes and rollers into the paint on your palette, and then apply them to the surface as desired.

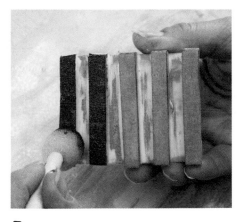

3 Brush a different color of paint on the art foam stamps.

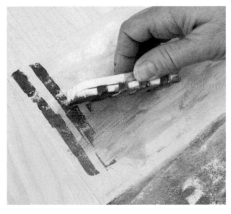

4 Stamp the background.

TROUBLESHOOTING

If you're not getting great coverage because the paint is drying too quickly, add some glazing medium to the paint to extend its drying time. Then again, maybe the grungy effect you get with the dry paint is a happy accident.

If you get irregular coverage of paint when rolling or stamping, it could mean you don't have paint evenly covering the roller or stamp, or that your surface has too much texture.

VARIATIONS

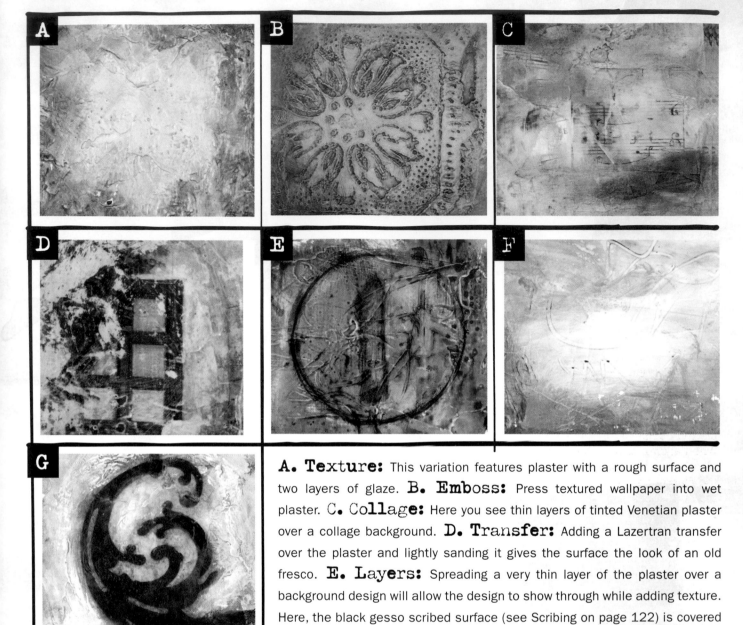

A. Texture: This variation features plaster with a rough surface and two layers of glaze. **B. Emboss:** Press textured wallpaper into wet plaster. **C. Collage:** Here you see thin layers of tinted Venetian plaster over a collage background. **D. Transfer:** Adding a Lazertran transfer over the plaster and lightly sanding it gives the surface the look of an old fresco. **E. Layers:** Spreading a very thin layer of the plaster over a background design will allow the design to show through while adding texture. Here, the black gesso scribed surface (see Scribing on page 122) is covered with the Venetian plaster and a wash of magenta. **F. Erase:** Glaze used as an eraser over plaster: Apply untinted glazing medium to a painted surface and rub with a damp cloth. **G. Mysterious:** Ink-jet transfer into wet plaster: While Venetian plaster is wet, place an ink-jet image face down and burnish. Let it sit a few minutes and then pull the paper off.

Venetian Plaster

Venetian plaster gives you a unique finish that cannot be replicated with any other medium. It can be burnished to create a wonderful patina, it sands beautifully and you can add color to tint the plaster all the way through.

MATERIALS + TOOLS

palette knife

Venetian plaster

surface

mark-making tools

acrylic paint

stamps

sandpaper

glazing medium

paintbrush

paper towel

smooth metal spoon

SURFACES

This technique requires a rigid support:

canvas board

panel

ARCHIVAL QUALITY

Excellent

TIPS

You can burnish the plaster back to previous layers, even until it is white.

Some brands of Venetian plaster are more like paint products; other brands have more plaster. You will get slightly different results with each brand. Experiment until you find one you like.

1 Venetian plaster must be built up in thin layers. Apply a thin layer with a palette knife and let it dry. Apply 1–2 more layers, allowing the layers to dry thoroughly before adding the next. When adding color to the Venetian plaster, mix the color thoroughly into the plaster before applying it onto the surface.

2 Apply another thin layer and use the mark-making tools and press shapes into the wet plaster. Let it dry thoroughly and sand lightly if desired.

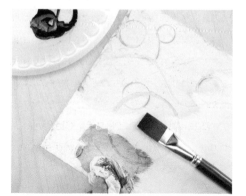

3 Mix the acrylic paint of your choice with the glazing medium. Paint the glaze over the surface. Let it dry slightly and use a paper towel to wipe off the surface, letting the color stay in the crevices. Apply other colors and glazes as desired and let them dry.

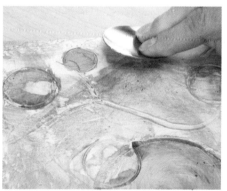

4 Burnish the surface using the back of the smooth metal spoon.

TROUBLESHOOTING

If the plaster is applied too thick, it will crack, but you can burnish small cracks out. Make sure you let the plaster dry thoroughly between layers.

VARIATIONS

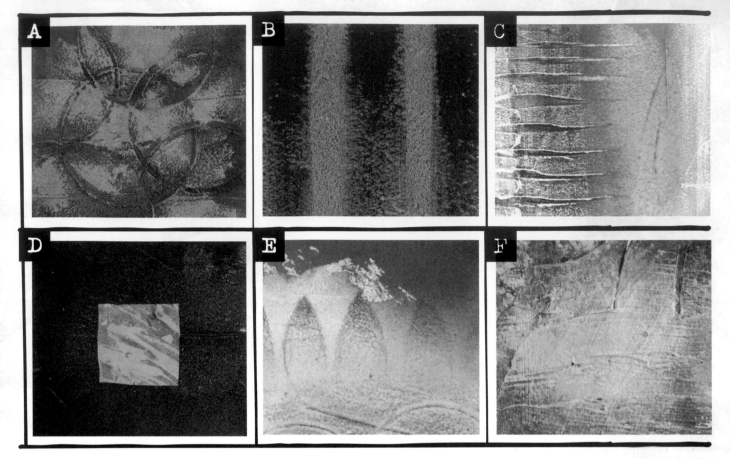

A. Deboss: Press shapes into the wet grounds; when the grounds have dried, paint the surface to highlight the shapes. **B. Tint:** Tint the ground with acrylic paint before applying. This variation uses coarse pumice. **C. Scribe:** Scribe into the wet ground (see Scribing on page 122) and let the ground dry before continuing. **D. Combine:** Try an interference violet paint on a black background for drama. Then glue a paint skin on top. **E. Draw:** After the ground is dry, you can draw on top of it using colored pencils, pastels or graphite. **F. Stain:** Apply paint to dry grounds and wipe off the excess paint.

Ceramic Stucco and Pumice Gel

Ceramic stucco and pumice gels with fine or coarse grounds can add great texture to your art. The texture will be grainy and takes the paint differently from a normal gesso surface.

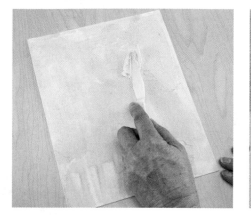

1 Using the palette knife, apply the ground or gel to the surface. If desired, scratch and deboss by pressing objects into the wet medium to make patterns. You can also apply the mediums through stencils to create patterns.

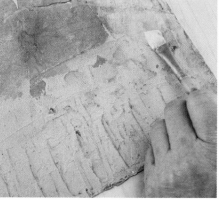

2 Allow the medium to dry thoroughly before continuing with paint as desired.

TROUBLESHOOTING

It's impossible to mess up this technique. But if you don't like the design you've created, just scrape off the medium and start again.

MATERIALS + TOOLS

palette knife

ceramic stucco or pumice gel (fine and coarse)

surface

objects

stencils

paintbrush

acrylic paint

SURFACES

canvas

watercolor paper

panel

ARCHIVAL QUALITY

Excellent

TIPS

It is fun to combine the different kinds of grounds in one piece of art.

The drying time of the medium will depend on its thickness. If you create deep grooves in your medium, be sure the thickest parts are completely dry before continuing.

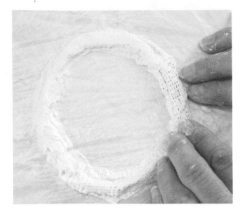

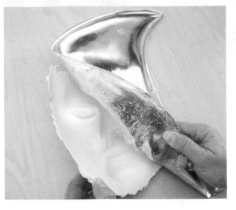

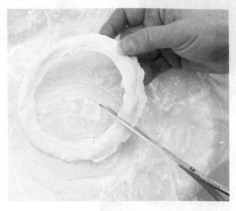

6 Build the desired shape with the wet plaster strips. When you're happy with the shape and size of the plaster strips, use your fingers to smooth the plaster as you did for the mask. Allow the shape to dry thoroughly on the plastic.

7 When the gauze is completely dry, gently pop the gauze off the mask.

8 Pull the circle shape off the plastic. You can now cut and paint the plaster as desired, incorporating it into your artwork.

VARIATIONS

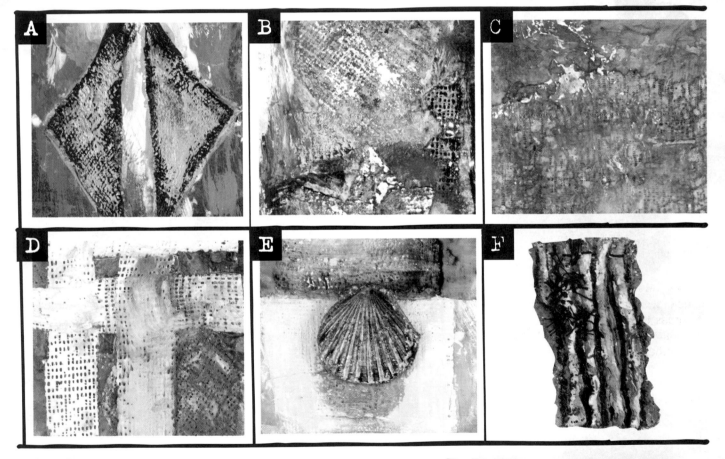

A. Shapes: Cut shapes several layers thick, and adhere together. **B. Stamps:** Cut a shape from the gauze; wet and press it onto the painting surface. Just before it dries fully, pull the gauze off. The plaster texture will remain. Allow it to dry, and continue as desired. **C. Faux Encaustic:** Use gel mediums over gauze to create a waxy look. **D. Collage:** Put strips and shapes onto wax paper. When they dry, adhere them to your surface. The side that was against the wax paper will be smooth, as opposed to the textured surface. **E. Sculpture:** Use a shell for a mold. **F. Play:** You can scrunch it up and even sew through it.

57

Plaster Gauze

You can sculpt with it, shape it, mold it, cut it into shapes or use it for texture.

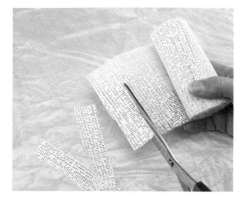

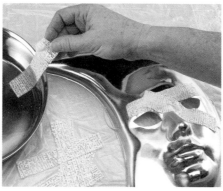

1 Lay the trash bag over your work surface to protect it. Using the scissors, cut the plaster gauze into strips long enough to cover the surface of the mask.

2 Working one strip at a time, dip the plaster gauze into the bowl of water and lay the strips on the mask.

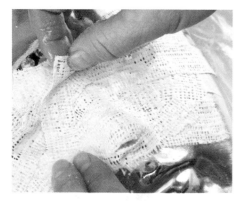

3 As you lay the strips onto the mask, overlap them. Use your fingers to press the plaster gauze down, smoothing it out where needed to blend them together.

4 Using your fingers, rub the plaster until it is smooth; dip your fingers in the water as needed. When you are happy with coverage of the plaster, allow it to dry thoroughly.

5 To make freeform pieces, cut the plaster gauze into strips as you did in step 1. Repeat step 2, but lay the plaster strips directly on the plastic bag.

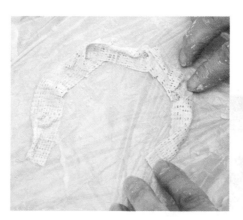

MATERIALS + TOOLS

trash bag

surface

scissors

plaster gauze

bowl of water

mask

paintbrush

acrylic paint

SURFACES

canvas

panel

watercolor paper

ARCHIVAL QUALITY

Good

TIPS

If you are making a mold from your hand or face, put petroleum jelly on your skin to prevent the plaster gauze from sticking to you.

The plaster powder that flakes off can be sprinkled on wet paint for a powdery surface.

TROUBLESHOOTING

Keep the plaster rigid and allow it to dry thoroughly to avoid cracks.

The finished pieces must be sealed and varnished to prevent cracking.

VARIATIONS

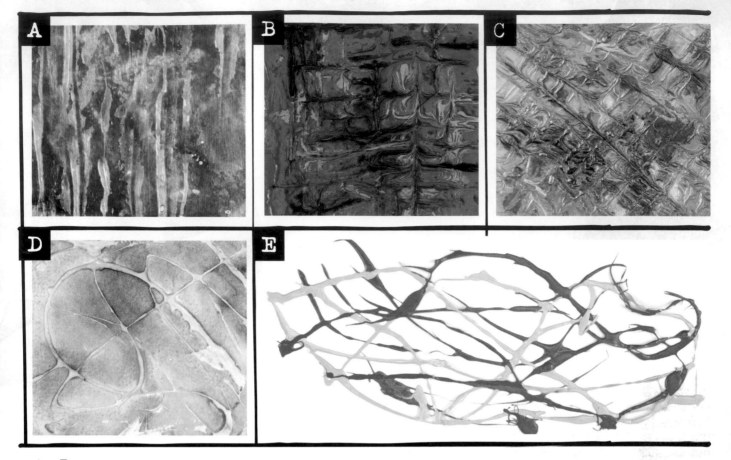

A. Layers: Mix paint into the gel string medium and spread it across your surface. Let it dry. Mix a different color into the gel and dribble it across the surface. If desired, drag the wet medium with a palette knife. Let it dry. **B. Marble:** Paint the surface and let it dry. Apply a coat of clear gel string medium and drop different colors of fluid acrylics into the wet gel. Use a toothpick to drag the colors into each other to create a marble effect. **C. Bling:** Try this technique over metal leaf (see Metal Leaf on page 38). **D. Resist:** Apply clear gel string medium and let it dry. Paint over the surface and let it dry. Wipe off the surface and the paint will come up off the gel string. **E. Sculpture:** Dribble the gel string medium onto wax paper in a freeform manner. When it is dry, you can use it as a sculptural element.

VARIATIONS

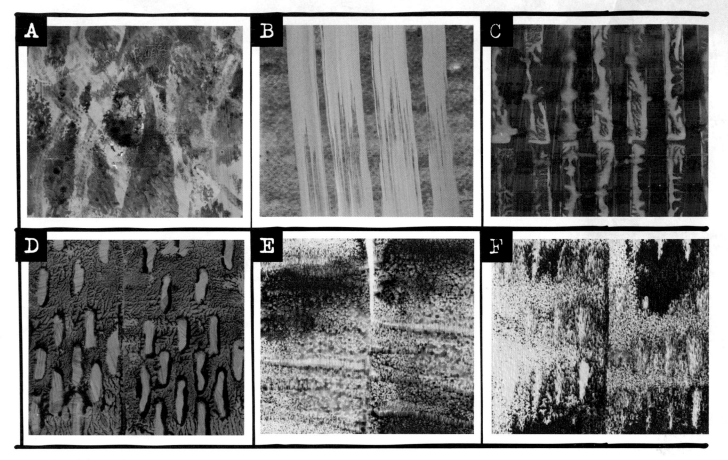

A. Rubber Band: Wrap a rubber band around your sponge roller. Every time you wrap one, you get a different pattern. **B. Stripes 1:** You can achieve this effect by cutting V shapes out of the sponge brush and dragging when you paint. **C. Stripes 2:** You can achieve this effect by gluing rectangular pieces of art foam to a stamp backing and stamping on the surface. **D. Groove:** Carve out shapes into your art foam and use them as stamps. **E. Horizontal Grooves:** You can achieve this effect by cutting linear shapes widthwise on a sponge roller. **F. Vertical Grooves:** You can achieve this effect by cutting linear shapes lengthwise on a sponge roller.

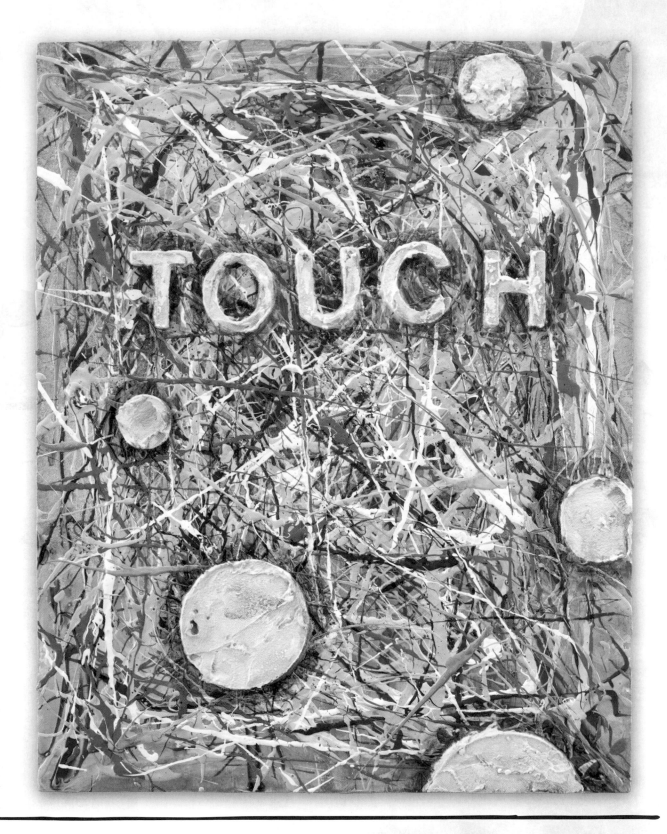

TOUCH
Sandra Duran Wilson

Main technique: Gel String (page 54)

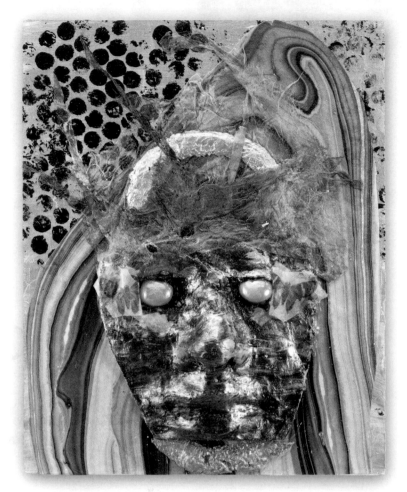

CARNIVAL
Sandra Duran Wilson

Main technique: Plaster Gauze (page 56)

DESERT SEA
Darlene Olivia McElroy

Main technique: Ceramic Stucco and Pumice Gel (page 58)

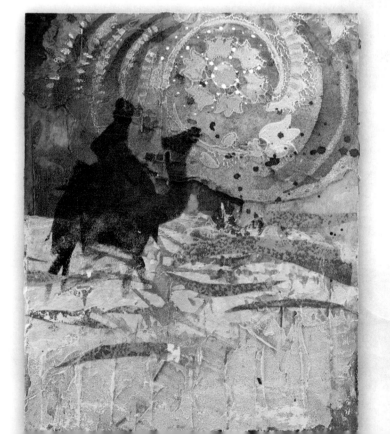

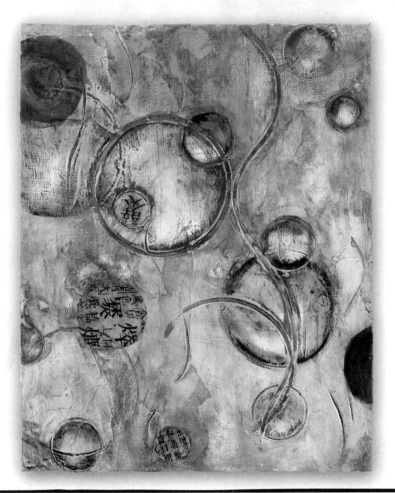

COSMOS
Sandra Duran Wilson

Main technique: Venetian Plaster (page 60)

ROCKIN' TAJ
Darlene Olivia McElroy

Main technique: Sponge Rollers and Art Foam (page 62)

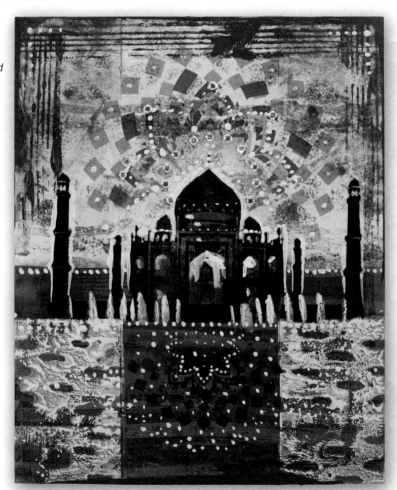

66

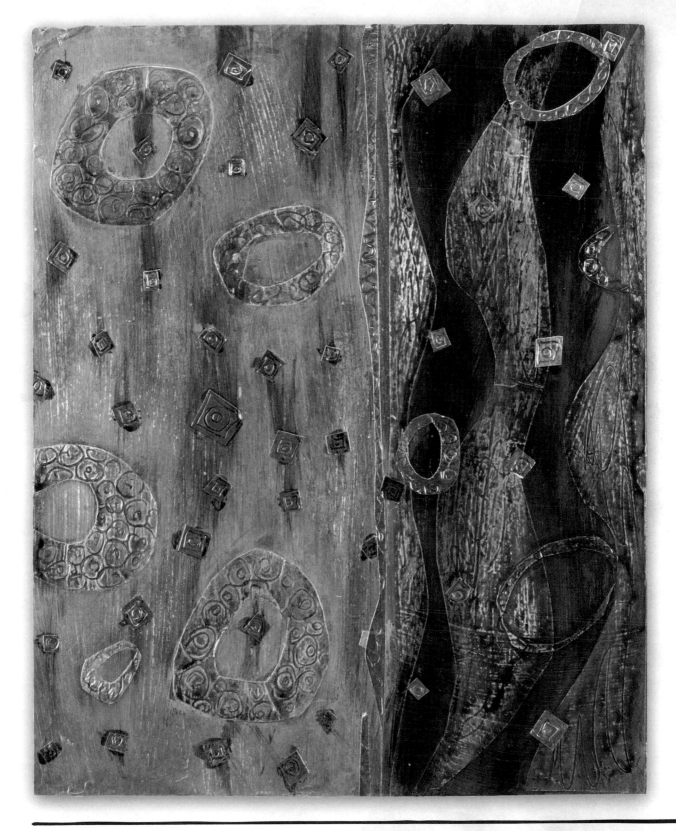

PHOTONS
Sandra Duran Wilson

Main technique: Ventilation Tape (page 68)

Ventilation Tape

The hardware store is another favorite resource for art supplies. Ventilation tape is used for taping air ducts together and can be found in the heating and cooling department. It is similar to working with aluminum foil, but ventilation tape has a paper back that peels off to expose the adhesive; this makes it great for working with small pieces. Some tape has writing on it, some are plain. Either will work—it depends if you wish to incorporate the writing or not.

MATERIALS + TOOLS

ventilation tape

paper towels

pencil, texture plates, fabric cutters or any tool that will create texture

scissors or bone folder

craft knife

surface

wood (optional)

paintbrush

acrylic paint

sandpaper (optional)

SURFACES

canvas

panel

watercolor paper

ARCHIVAL QUALITY

Excellent

TIPS

If the paint is not sticking, wipe it off, lightly sand and reapply. You may also try a coat of clear gesso to give it some tooth.

India ink is great for staying in the crevices.

You can overlap pieces of tape to cover larger areas.

1 Place a piece of the ventilation tape on the paper towels. Using a pencil, draw into the tape. You may emboss the tape by placing it over a stencil or texture plate and rubbing with your hand or a soft cloth for more depth.

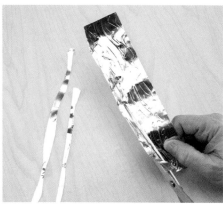

2 Cut the tape to the desired shapes.

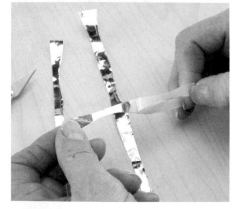

3 Remove the paper backing from the tape. Use the craft knife to help separate the tape from the backing.

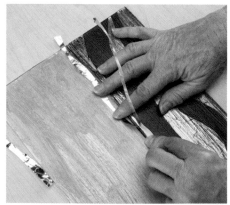

4 Press the tape down onto the surface.

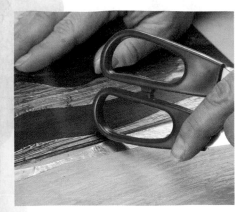

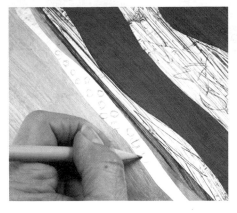

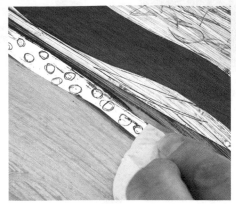

5 Burnish the edges with the handle of the scissors or a bone folder to ensure good adhesion. If you are doing this on stretched canvas, you will need a piece of wood underneath the canvas to have a solid surface to press against.

6 You may use tools to draw shapes and press texture into the tape.

7 Using the paintbrush, add a layer of acrylic paint to the tape. Let the paint sit for about 15 minutes and then wipe it off with a paper towel, leaving paint in the crevices. You can add more layers of paint and sand back lightly to reveal the tape.

TROUBLESHOOTING

If all the paint comes off when you wipe, you need to let it dry longer.

Do not put gloss medium directly over the tape, because the gloss medium won't stick. You will need to put another medium over it, like paint or clear gesso, and allow it to dry before applying the gloss medium.

The tape is very sticky, so take care when pulling off the backing—it has a tendency to curl up. It is easier to work with small pieces of tape.

VARIATIONS

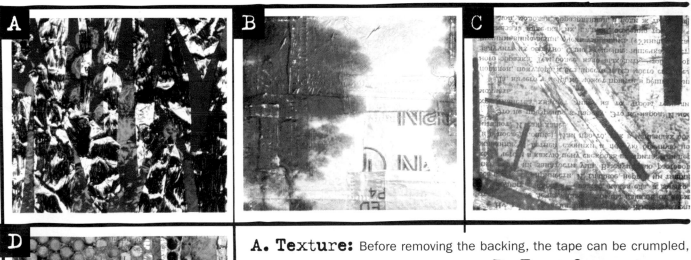

A. Texture: Before removing the backing, the tape can be crumpled, unfolded, painted and cut into shapes. **B. Transfer:** Use a dress pattern tool to texture the tape, and then put a water slide transfer on top. **C. Layers:** Adhere strips on top of book pages and then glue on a transparency. **D. Collage:** Use the tape as a functional element by taping down collage pieces.

69

Embossing

Embossing can be done with paints, gels, pastes and gesso. You can layer this technique over areas of a painting to create new texture. If you use transparent gels and glazes, you can see the layers below. The right drying time and thin layers are the tricks for success.

MATERIALS + TOOLS

palette knife
medium of choice
surface
textured paper or fabric
sandpaper (optional)

SURFACES

canvas
metal
paper
panel

ARCHIVAL QUALITY

Excellent

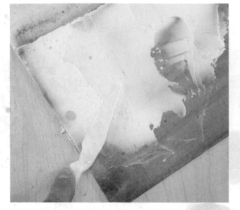

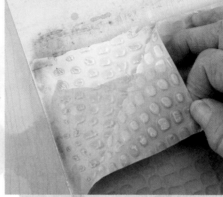

1 Apply a thin layer of medium (I used molding paste) with a palette knife.

2 Let the medium dry slightly until it develops a skin. Place the textured paper over the medium and gently rub the back of the paper. Peel off the paper to reveal the texture.

3 Let the medium dry. If desired, lightly sand the surface before continuing with your artwork.

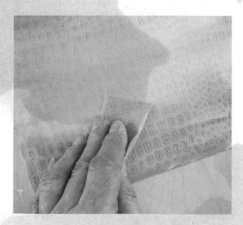

TIPS

If you are using a paper or fabric with openings, such as lace, place a piece of scrap paper or plastic wrap over the paper or fabric before rubbing it to keep your hands clean.

If you are covering a large area with molding paste, you should use a rigid surface or use light molding paste so it doesn't get too heavy.

Flexible molding paste works best on surfaces like paper or canvas.

TROUBLESHOOTING

If your texture doesn't come out as you like, scrape it off and start over. This time, try applying a thinner layer.

Timing is essential in this technique. If the gel or medium is too dry, it won't emboss. If it is too wet, the texture will appear only as "pulling" or sticky lines.

VARIATIONS

A. Mirage: Use gel gloss to allow the painted background to show through for a dreamy effect. **B. Texture:** Apply a light molding paste over a painted surface. When objects are pressed into the wet paste, the background is revealed. When you add a thin layer of paint, you get even more texture. **C. Bling:** Embossed gel over metal leaf adds depth and texture to your surface. **D. Age:** Layering, painting and sanding give you a rustic look. **E. Drama:** Iridescent Bronze breaks down into two colors to add depth and drama.

Attaching and Gluing

All acrylic polymer mediums can act as glues. Matching the appropriate gel, paste or medium to the object to be glued is the key. If you are gluing a thin paper such as gampi tissue, then use a polymer medium. If you are attaching a button or other thick object, then use a gel. The heavier the object, the thicker the gel. Some objects may need an epoxy, a nail or a screw.

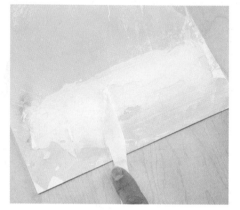

1 If you want a colored background, paint it as desired and let it dry. Using the palette knife or paintbrush, apply the medium of choice (see below for procedures).

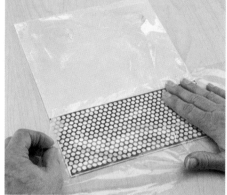

2 Lay the paper or object onto the surface and press the paper or object into the gel. If needed, place a piece of plastic wrap over the object to prevent getting medium all over your hands.

MATERIALS + TOOLS

paintbrush

acrylic paint

surface

palette knife

gels

object or paper to be glued

plastic wrap

SURFACES

canvas

panel

paper

ARCHIVAL QUALITY

Excellent

TIPS

Remember that how you attach objects can be part of your design.

Keep your work surface cleaner by using an old phone book. Place the paper face down onto the open phone book, and then apply the gel.

A great site for glue is www.thistothat.com.

TROUBLESHOOTING

If the adhesive isn't working, it is probably the wrong glue for your surface. It's best to try a test first before adhering your objects. If it's already dry, you can sand off the glue and try a different glue. If you are worried that it might not be strong enough, try combining two techniques such as gluing onto a panel and screwing in from the back side.

VARIATIONS

A. Light Touch: Use a polymer medium to adhere silk tissue paper or rice papers. **B. Heavy Touch:** Adhere heavier papers and small objects with gel mediums. **C. Sew:** Stitching can be used as both a way to attach and as a design element. **D. Spray:** Attach gold leaf using spray glue through a stencil (see Metal Leaf on page 38). **E. Two Sides:** Using a two-sided adhesive film is good for dry attachment of transparencies and fabrics. **F. Stick It:** Glue sticks and hot-glue guns can adhere even the smallest embellishments, like pigment powder. **G. Heat It:** You can iron elements together using acrylic paint or mediums—just use a silicone sheet between the paints or mediums and the iron (see Fusible Webbing on page 114). **H. Staples:** Staples and other office supplies can have the dual purpose of attaching items and adding drama. **I. Heavy Metal:** Use an epoxy to adhere metal to metal or jewelry to ceramic.

| # Glazes

Glazing adds depth and interest to your surface and it is especially effective over textures. It looks very different applied over absorbent and nonabsorbent surfaces. It will also change the underlying color.

MATERIALS + TOOLS

palette knife

acrylic paint (transparent colors work best)

surface

acrylic glazing medium

paper towel

SURFACES

canvas

panel

watercolor paper

ARCHIVAL QUALITY

Excellent

1 Prepare the surface as desired. This background was created over a collage using both gloss gels and molding pastes (see Pastes on page 44).

2 Prepare the glazes by laying out the desired acrylic paints on the palette. Add a few drops of the acrylic glazing medium to each color. Using the palette knife, mix the individual colors with the glazing medium. Wipe the palette knife clean between mixing colors.

TIPS

Glazing mediums come in gloss, satin and matte. I prefer gloss to keep the glaze as transparent as possible. When looking for paints to mix with the glazing medium, I choose the most transparent colors.

Glazing is the way to tone down a color. Try putting the complementary color in a glaze and then applying it over the area you want to toned down.

Glazing medium without color can act as an eraser. If you apply a color to a nonabsorbent surface and decide you want to take it off, add some glazing medium to a damp cloth and rub off the color.

For porous surfaces, mist the surface with water before applying the glaze.

3 Using the paintbrush, apply the glazes over the background. Let it sit for a few minutes, and then gently wipe off some of the glaze with a damp paper towel. Let it dry.

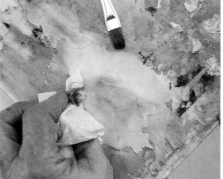

4 You can apply several layers using different colors.

TROUBLESHOOTING

If you wish to use an opaque color, add just a tiny bit into your glazing medium.

Glazing mediums take a long time to dry. Don't rush to put more layers on, or you could end up with a mess.

VARIATIONS

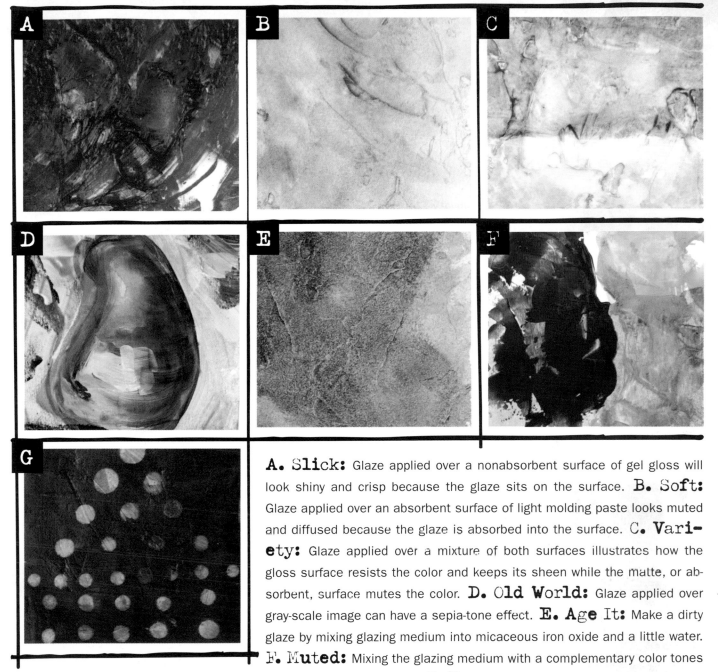

A. Slick: Glaze applied over a nonabsorbent surface of gel gloss will look shiny and crisp because the glaze sits on the surface. **B. Soft:** Glaze applied over an absorbent surface of light molding paste looks muted and diffused because the glaze is absorbed into the surface. **C. Variety:** Glaze applied over a mixture of both surfaces illustrates how the gloss surface resists the color and keeps its sheen while the matte, or absorbent, surface mutes the color. **D. Old World:** Glaze applied over gray-scale image can have a sepia-tone effect. **E. Age It:** Make a dirty glaze by mixing glazing medium into micaceous iron oxide and a little water. **F. Muted:** Mixing the glazing medium with a complementary color tones down the color underneath. **G. Erase:** You can use the glaze as a resist. While the surface color is still wet, drop untinted glazing medium onto the surface. Let the paint dry, but before the glazing medium dries, wipe it off.

ADDITIVE | Embedding

By embedding objects and papers into your surface, you create interesting textures that seem to be custom built to your artwork—almost like having architectural elements for art.

1 With the appropriate adhesive, secure the desired objects to the surface. Let the adhesive dry.

2 Using the palette knife, apply molding paste or ceramic stucco to blend the edges and add more texture. Let it dry before continuing with your artwork.

MATERIALS + TOOLS

adhesive (see Attaching and Gluing on page 72)

objects such as embossed paper, fabric, embroidered fabric, photos, stencils, buttons and stamps

surface

palette knife

molding paste or ceramic stucco

SURFACES

canvas

panel

watercolor paper

ARCHIVAL QUALITY

Excellent

TIPS

Certain objects that are slick or plastic may need a different kind of adhesive.

TROUBLESHOOTING

It always helps to let the glue dry before you before you move onto step 2, or objects may move around.

VARIATIONS

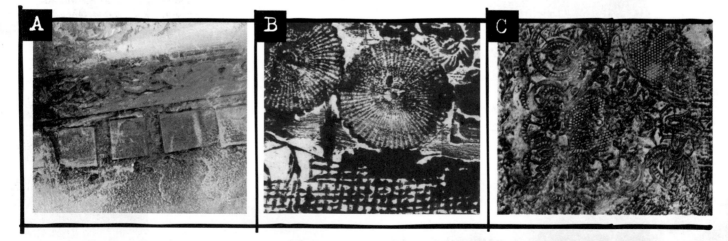

A. Enhance: Use a dry paintbrush to add paint to the surface, enhancing the textures. **B. Print:** After doing this technique, you can make a print of the surface, also known as a collograph. To do this, paint the surface (add a little glazing medium to extend the drying time), lay the paper over it and brayer well. Do the stamping before you continue with the original piece of artwork. **C. Texture:** Lay molding paste down. When it starts

to form a skin, place your texture (in this case, a heavy paper doily), pat it down and then lift the texture. If the molding paste hasn't set up enough, you won't see the imprint.

Final Finishes

When you finish a piece of artwork, you may have several different sheens from gloss to matte. To unify them, apply a gloss coat over everything and let it dry completely. Then spray with a varnish. You can use gloss, matte or satin varnish; the matte really dulls the colors, so unless you want that effect, stick with satin or gloss.

MATERIALS + TOOLS

self-leveling gel

water

cup for mixing

palette knife, rubber brush or brush

surface

alcohol

SURFACES

canvas

panel

ARCHIVAL QUALITY

Excellent

1 Mix the self-leveling clear gel with water—about 20 percent water and 80 percent gel. Do this by tilting the gel cup and then pouring the water in slowly.

2 Gently mix the water and gel with a palette knife. You don't want to introduce air bubbles into the mixture.

TIPS
Place the artwork on a level surface protected by plastic so the gel won't stick to the surface. Placing the artwork on top of a jar or on blocks will keep gel that drips over the edge from gluing the artwork and plastic together.

Varnishes can protect against dirt and UV damage. Some artists will add an isolation layer of soft gel gloss. This assures that if you need to remove the varnish for restoration, the painting will not be affected.

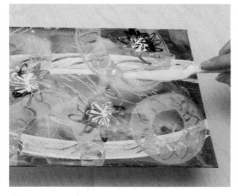

3 Pour the mixture onto the surface. Use the palette knife, rubber brush or brush to gently spread the mixture evenly over the surface.

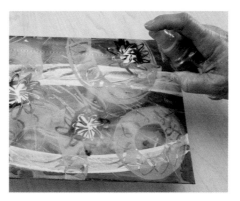

4 If bubbles form, spray the area with alcohol. Rest the artwork on a level surface and allow the mixture to dry thoroughly.

TROUBLESHOOTING
If you have stirred your self-leveling gel mixture too vigorously, let it sit for a few hours to allow the air bubbles to come to the surface.

Use spray varnish outside or in a spray booth. To get adequate coverage, spray at least four times, rotating the work with each application. If you use liquid varnish, you don't need as many coats, but do not apply it too thick, or it will pool in the crevices on your textured work.

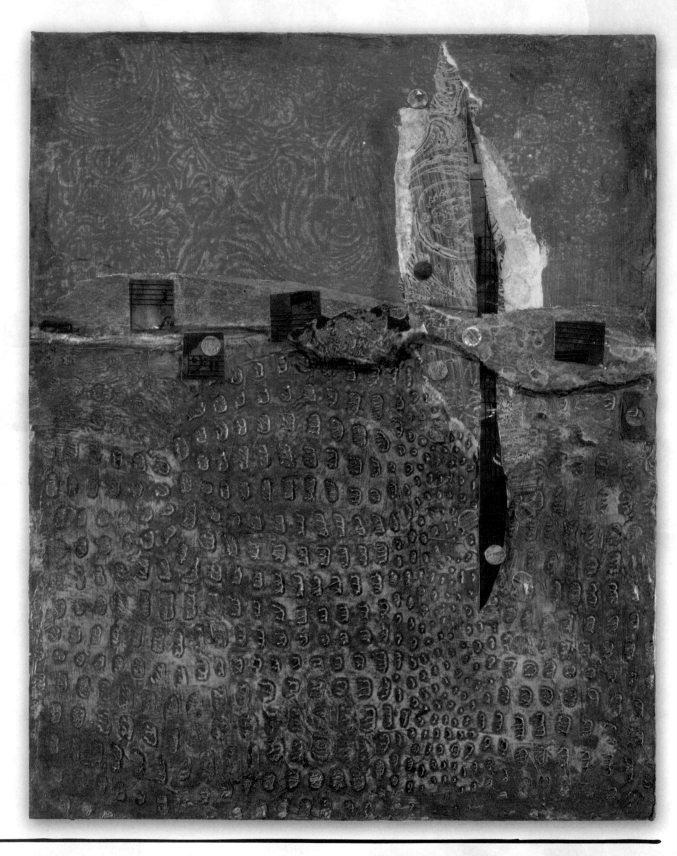

DANCE IN THE DESERT
Sandra Duran Wilson

Main technique: Embossing (page 70)

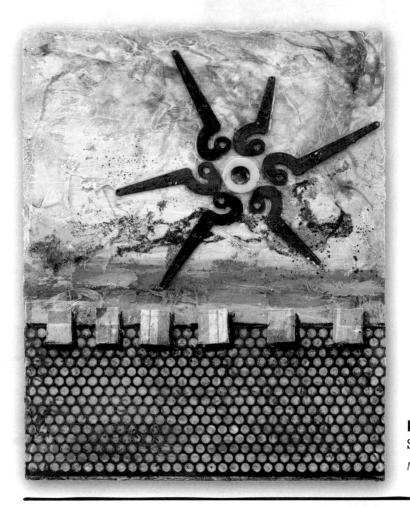

KEEPING TIME
Sandra Duran Wilson

Main technique: Attaching and Gluing (page 72)

TRES LUNAS
Sandra Duran Wilson

Main technique: Glazes (page 74)

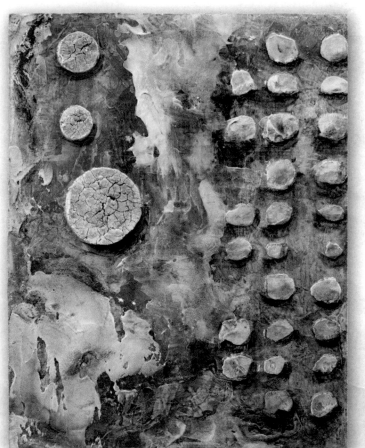

TRAVELER
Darlene Olivia McElroy

*Main technique: Embedding
(page 76)*

THAT'S ENTERTAINMENT
Darlene Olivia McElroy

Main technique: Final Finishes (page 77)

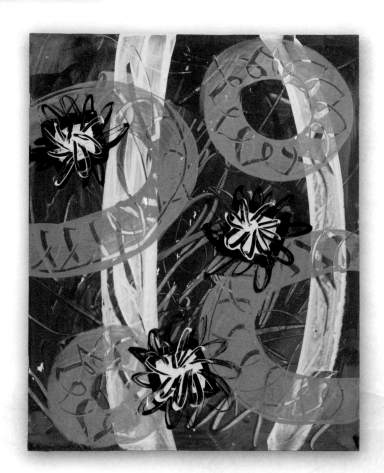

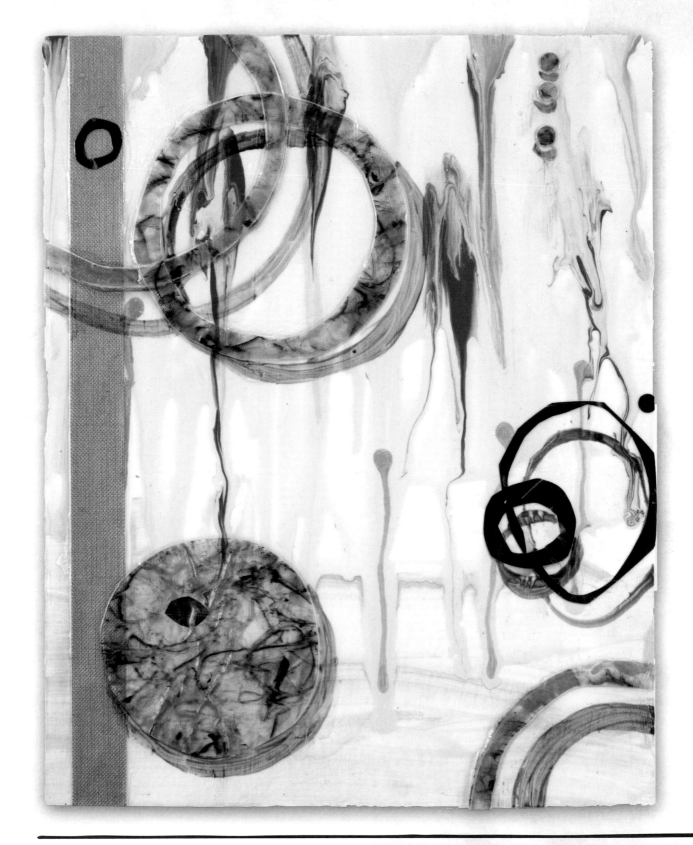

ORBITS
Sandra Duran Wilson

Main technique: Pours (page 82)

ADDITIVE | Pours

Acrylic pours and drips can be used in many different ways: Pours can be cut into shapes and used as collage elements; you can mix different mediums to get runs and drips; and you can create marbled effects with pours. Clear pours are covered under Final Finishes (page 77).

1 Choose your surface and colors. Using the palette knife, mix one fluid acrylic paint color (we chose blue) with Golden GAC 800 in a small container. Clean the palette knife and mix another fluid acrylic paint (we chose white) with Liquitex Pouring Medium in different container.

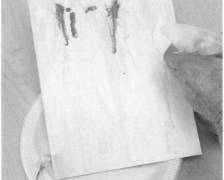

2 Drip or pour a small amount of each mixture at the top of the surface. Hold the surface over a disposable plate or container, and tilt and move it to get the paint to flow. You may also spritz on water to increase the flow. Let it dry.

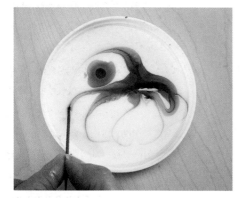

3 Pour Liquitex Pouring Medium into the plastic lid—enough to cover the bottom. While the pouring medium is still wet, drop the desired colors of fluid acrylic paints in separate drops. Take a toothpick and swirl the colors. Allow the pouring medium to dry (this could take several days, depending on the thickness). It will be clear, not cloudy, when dry.

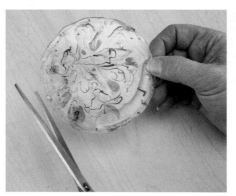

4 Pop the pour out of the lid. You can cut the pour into shapes using scissors.

MATERIALS + TOOLS

surface

fluid acrylic paint

palette knife

Golden GAC 800

cups for mixing (yogurt containers with lids work well)

Liquitex Pouring Medium

disposable plate

plastic lid

scissors

SURFACES

canvas

panel

plastic

watercolor paper

ARCHIVAL QUALITY

Excellent

TIPS

To keep paint colors pure, let each color pour or drip dry before adding the next one.

Golden GAC 500, alcohol and water are also good additives to get paint you pour to run.

Trash bags and plastic drop cloths are the type of plastic acrylic won't stick to, and most plastic food lids will also release the acrylic.

VARIATIONS

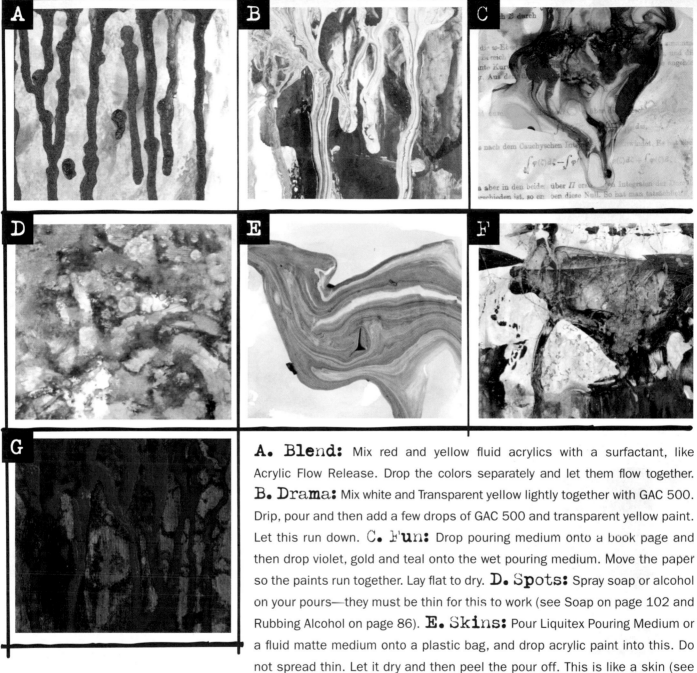

A. Blend: Mix red and yellow fluid acrylics with a surfactant, like Acrylic Flow Release. Drop the colors separately and let them flow together. **B. Drama:** Mix white and Transparent yellow lightly together with GAC 500. Drip, pour and then add a few drops of GAC 500 and transparent yellow paint. Let this run down. **C. Fun:** Drop pouring medium onto a book page and then drop violet, gold and teal onto the wet pouring medium. Move the paper so the paints run together. Lay flat to dry. **D. Spots:** Spray soap or alcohol on your pours—they must be thin for this to work (see Soap on page 102 and Rubbing Alcohol on page 86). **E. Skins:** Pour Liquitex Pouring Medium or a fluid matte medium onto a plastic bag, and drop acrylic paint into this. Do not spread thin. Let it dry and then peel the pour off. This is like a skin (see Skins on page 46). **F. Webs:** Use spray webbing on a pouring medium (see Spray Webbing on page 48). **G. Runs:** Dilute the paint with a little water. Apply it to the surface and spray it with alcohol to get it to run.

TROUBLESHOOTING

If you end up with a muddy mess while pouring on a surface, you have used too many colors at once. Try using one or two colors at a time, and let these dry before adding more. If the paint is still wet when the mess happens, try wiping it off with water or alcohol and then start the process again.

Shaving Foam

Shaving foam painting is a fun art activity for kids and adults. Paper artists have used it for an easy marbling technique. Here you'll discover how to create some unusual backgrounds and unique collage papers using shaving foam. Get foam, not gel, and unscented if you can.

MATERIALS + TOOLS

shaving foam (unscented, if possible)

clear plastic plates

paper towels

palette knife

fluid acrylic paints, watercolors or dyes

surface

SURFACES

canvas

paper

panel

ARCHIVAL QUALITY

Good if some of the foam is left on the surface; excellent if the foam is wiped off completely.

TIPS

You can continue using the same shaving foam and adding more colors until it gets muddy.

Liquid acrylic inks and dyes work great for the marbling effect.

If this is a technique you do often, use a piece of Plexiglas instead of a clear plastic plate; just rinse off the foam to reuse.

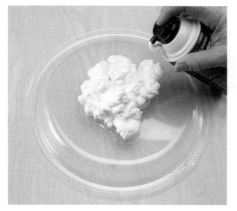

1 Spray the shaving foam onto the back of the plastic plate. Keep the paper towels nearby to clean up your work surface as needed.

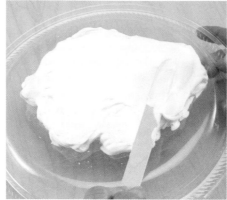

2 Use the palette knife to spread the foam to an even layer, about ½" (1.3cm) thick.

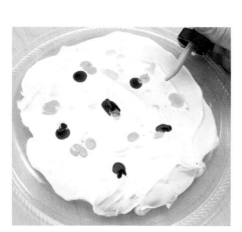

3 Place drops of the paints, inks or dyes onto the shaving foam.

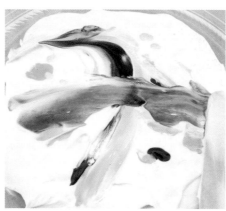

4 Swirl the paint with the palette knife.

TROUBLESHOOTING

If you get scented foam, the smell can become overpowering after a bit. Put your used towels in a plastic bag so they don't continue to perfume your studio.

Happy accidents will abound with this technique; enjoy the outcomes—they may be better than what you had planned.

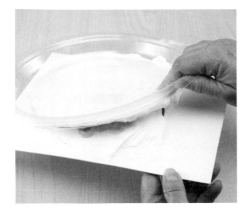

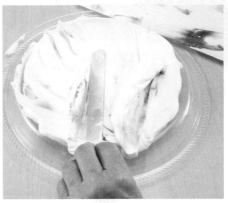

5 Place the shaving cream onto the surface. You can swirl the plate around or press it down and lift it off.

6 Pull the plate off the surface and use the palette knife to gently scrape the shaving foam from the background surface.

7 Place the excess shaving foam back on the plate. Repeat adding color, swirling, applying to the background and wiping off the foam until you are happy with the result. Scrape off the foam. Continue the artwork as desired.

VARIATIONS

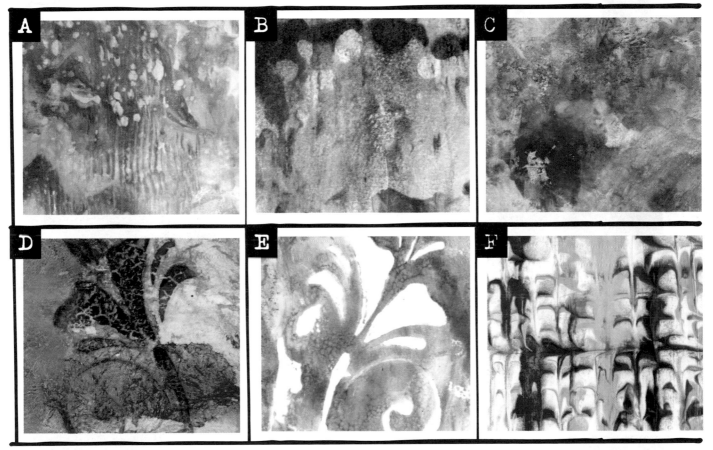

A. Patterns: Drag a notched tool through the shaving foam to create marks, and spritz with alcohol to create drop patterns. **B. Play:** Use interference colors for a shimmering effect. **C. Texture:** Let the foam dry and break down. Brush off the residue and then spray the surface with an acrylic coating to seal it. **D. Stencil:** Tape a stencil onto the surface and then place the plate with the colored foam on top. Remove the stencil, but don't wipe the foam off. Let the foam dry and spray the surface with an acrylic spray finish like Krylon 1303. **E. Stamp:** Using the stencil from variation D, press the stencil with the leftover foam onto a clean surface to get the reverse image. **F. Marble:** Drag the tip of a knife through the color drops on the shaving foam to create a marble-paper effect.

Rubbing Alcohol

This technique is another favorite because it produces such varied results, from large circles with dots in the middle to small starlike clusters. Paint viscosity is the key to success for this technique, and the combination of colors is what makes it beautiful.

MATERIALS + TOOLS

paintbrush

acrylic paint

surface

eyedropper

rubbing alcohol

spray bottle

SURFACES

canvas

panel

watercolor paper

ARCHIVAL QUALITY

Excellent

TIPS

Use different tools to apply the rubbing alcohol, such as spray bottles, toothbrushes, fan brushes and eyedroppers.

Try using different paint viscosities without making the paint too thick.

Spraying the rubbing alcohol up in the air and catching it on the surface as it falls gives the artwork a wonderful, lightly speckled appearance.

The effect is more dramatic on a slick surface than on a porous one.

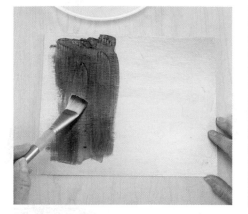

1 If you choose to begin with a background color, paint the surface and let it dry completely. Using a clean paintbrush, paint your surface with a thin coat of diluted paint, the consistency of cream.

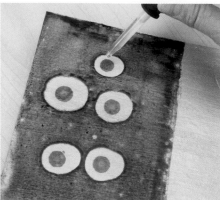

2 While still wet, spray or drop the rubbing alcohol onto the paint. Wait a few seconds, and the paint will begin to form pools.

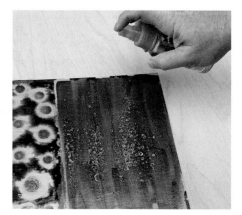

3 Let it dry, and repeat with a different color if desired. Using a spray bottle results in a misted look.

TROUBLESHOOTING

Do not let the paint dry prior to spraying with alcohol. If paint is too wet, it will all run together instead of forming pools.

If the paint is too thick, the alcohol can't penetrate it—the alcohol will just sit on top.

If you don't like the result, wipe off the surface before the paint dries and try again.

VARIATIONS

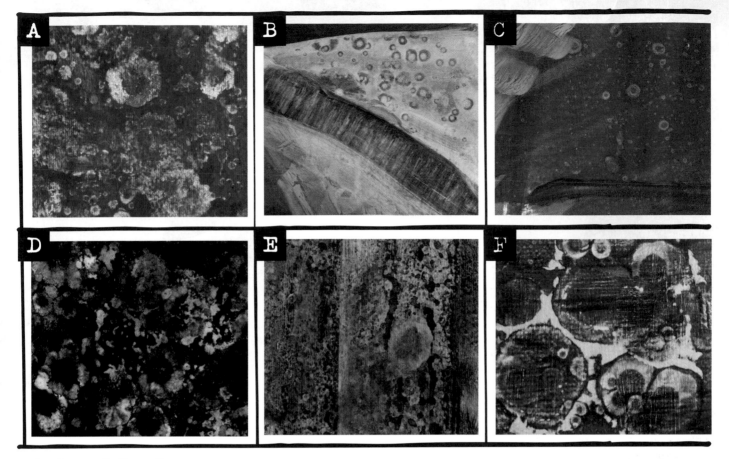

A. Metal Leaf: When using metal leaf as your background (see Metal Leaf on page 38), you may need to spray the leaf with a workable fixative prior to painting it. **B. Revive:** Use this technique over backgrounds or areas of old paintings—it could be a new start for a piece of art you had given up on. **C. Experiment:** Try different dark colors and interference colors. **D. Mysterious Finish:** After spritzing with alcohol, wipe off the paint before it is completely dry. You will get the outlines of circles. **E. Color Drama:** Layering high-contrast colors like crimson, cobalt, teal and iridescent bronze adds drama to your art. **F. Play:** A really wet paint will give you slightly wavy circles, and a drier paint will give sharper edges.

RESIST | Bleach Pen

This is another resist technique that allows you to see the underlying painting. You can buy these pens in the laundry section of the market. They have a gel that holds the bleach and won't run—this makes them great for writing or mark making. Bleach is a toxic chemical, so work outside or where you have excellent ventilation.

MATERIALS + TOOLS

paintbrush

acrylic paint

surface

bleach pen

paper towel

SURFACES

canvas

panel

watercolor paper

ARCHIVAL QUALITY

Poor to good

TIPS

For a less toxic way to get the same effect, use an untinted glazing medium instead of the bleach pen. It will work the same way, but it is not easy to write with. You can use it easily to make dots.

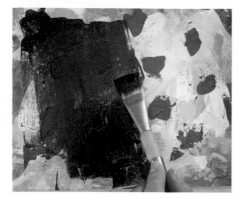

1 Paint the surface as desired and let it dry. Dilute an acrylic paint in a contrasting color and paint a layer of it onto the surface.

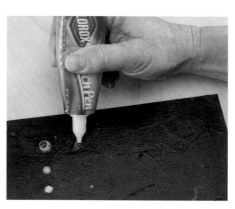

2 While the paint is wet, use the bleach pen to make dots on the surface.

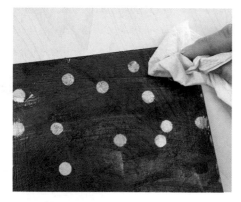

3 Let the paint dry. Using a damp paper towel, wipe off the bleach. (Do not use anything other than water to dampen the paper towel.)

TROUBLESHOOTING

Make sure the paint is sufficiently dry before wiping off the bleach, or you will wipe everything off.

VARIATIONS

A. Design: You can draw designs and even write with this technique.

B. Wavy: Adding the bleach to very wet paint makes wavy edges.

C. Crisp: Bleach on a slightly thicker paint gives you a hard edge.

D. Texture: For textured circles, leave the bleach on until it is thoroughly dry, and spray with a clear acrylic coating. This won't be archival, but it creates a wonderful texture.

Petroleum Jelly

Petroleum jelly is a resist that preserves areas of the underlying art, creating a wonderful, weathered paint look. This technique is great for highlighting areas of your artwork.

MATERIALS + TOOLS

paintbrush

acrylic paint

surface

petroleum jelly

baby wipes

SURFACES

canvas

panel

watercolor paper

ARCHIVAL QUALITY

Excellent

TIPS

Baby wipes make wiping up the petroleum jelly easy, but you can use soapy water and paper towels if none are available.

1 Paint or decorate the surface as desired. Wipe petroleum jelly on the areas of your background that you want to protect, leaving other areas petroleum-jelly free.

2 Paint the surface with acrylic paint, and then let it dry. The petroleum jelly will remain gooey.

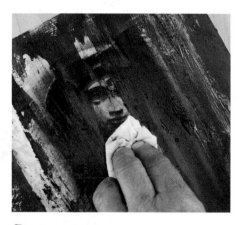

3 Wipe off with baby wipes.

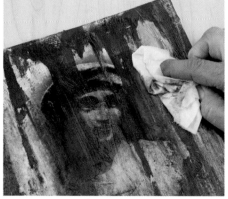

4 If desired, repeat using different colors.

TROUBLESHOOTING

If you have a painting with a focal point you want to preserve, make sure you have petroleum jelly (the resist) on the image.

If you misplaced the petroleum jelly or don't like the finished look, you can remove the paint with alcohol. The alcohol will take off the paint down to the surface unless you add an isolation coat of polymer medium or gel prior to this technique.

VARIATIONS

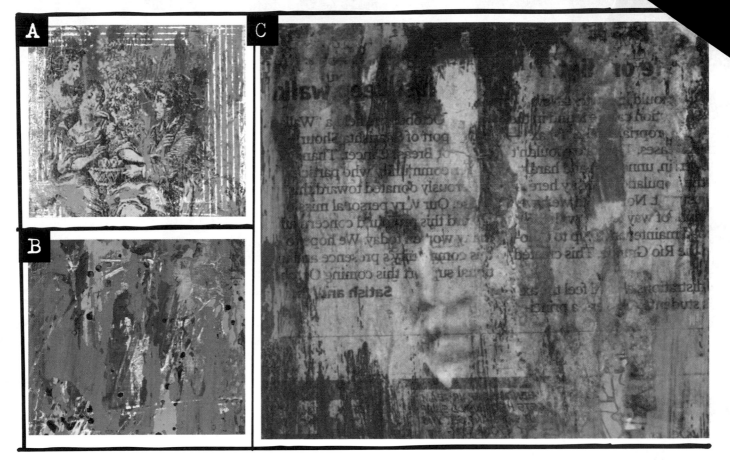

A. Stamp or Stencil: After step 2, stamp on a pattern with acrylic paint and let the paint dry. Continue to step 3 for added interest. **B. Drama:** Layer opposite colors on the color wheel to enhance your art. **C. Combine:** This technique looks great when combined with pulled paper elements (see Pulled Paper on page 50).

astic Wrap

...se of the drama that plastic wrap adds to a ... adding soft or hard edges, linear or abstract lines,g, the look is never the same.

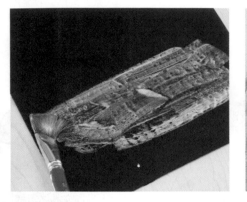

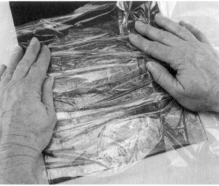

1 Using the paintbrush, add paint to the surface.

2 While the paint is wet, lay the plastic wrap over the paint. Pat down the plastic wrap or stretch in to a linear pattern.

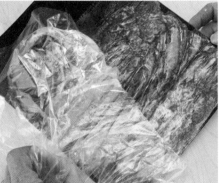

3 After allowing the paint to dry, peel the plastic wrap from the surface. If you peel the plastic wrap while the paint is still somewhat wet, you will get a soft texture. If the paint is dry when you peel off the plastic wrap, the texture will be crisp.

Allow the paint to dry thoroughly before continuing with your art.

TROUBLESHOOTING

If the paint is too dry before you add the plastic wrap in step 2, you will get little to no texture. Make sure you lay the plastic wrap on just after you've finished painting. The texture forms as the paint dries.

If you are concerned about not liking the patterns, paint an isolation coat of medium or gel over the surface and allow it to dry before doing this technique. You can re-move the paint with alcohol.

VARIATIONS

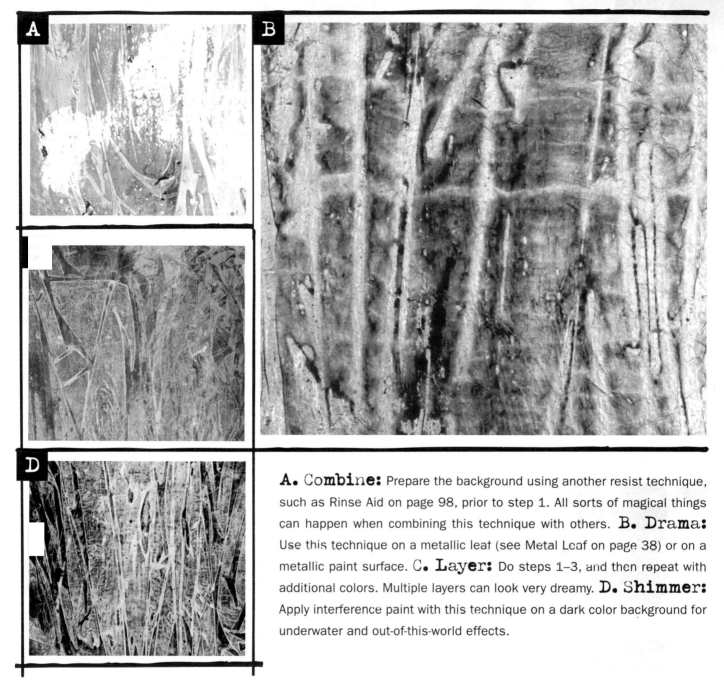

A. Combine: Prepare the background using another resist technique, such as Rinse Aid on page 98, prior to step 1. All sorts of magical things can happen when combining this technique with others. **B. Drama:** Use this technique on a metallic leaf (see Metal Leaf on page 38) or on a metallic paint surface. **C. Layer:** Do steps 1–3, and then repeat with additional colors. Multiple layers can look very dreamy. **D. Shimmer:** Apply interference paint with this technique on a dark color background for underwater and out-of-this-world effects.

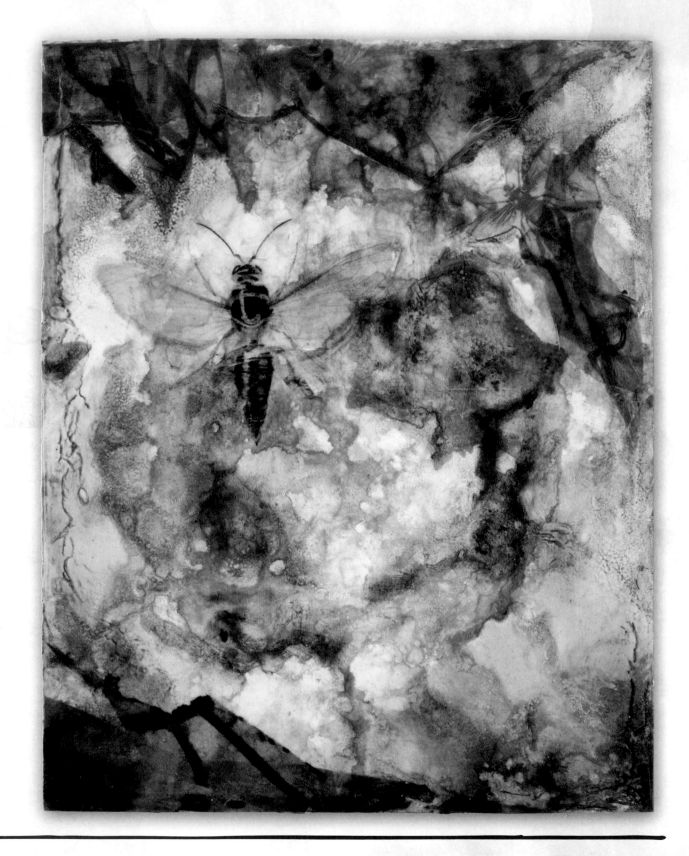

JUNGLE JUICE
Sandra Duran Wilson

Main technique: Shaving Foam (page 84)

SONG DELIGHT
Sandra Duran Wilson

Main technique: Rubbing Alcohol (page 86)

MONDRIAN MADNESS
Sandra Duran Wilson

Main technique: Bleach Pen (page 88)

95

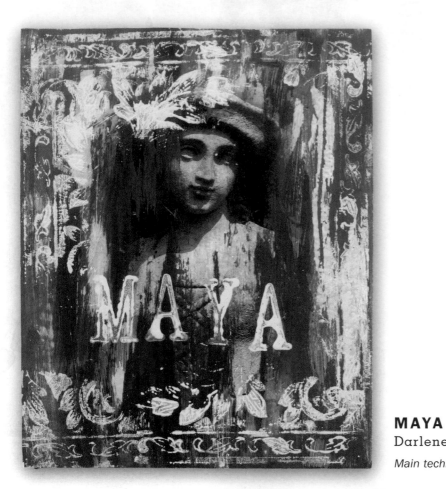

MAYA
Darlene Olivia McElroy

Main technique: Petroleum Jelly (page 90)

GONE FISHING
Darlene Olivia McElroy

Main technique:
Plastic Wrap (page 92)

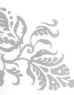

96

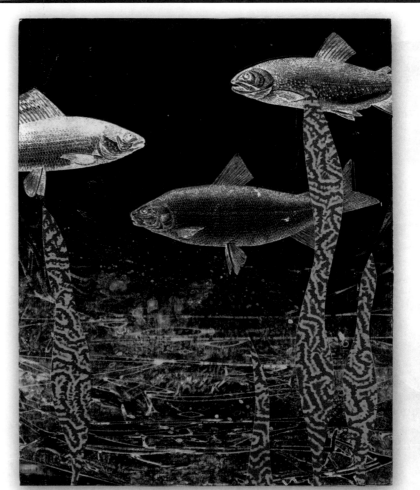

FLOWER POWER
Sandra Duran Wilson

Main technique: Rinse Aid (page 98)

Rinse Aid

This technique has been around for a while, and it makes a great distressed look. It's fun to layer it with more than one color or to combine it with other techniques. It's also a way to build layers while preserving the underlying techniques. The trick to this technique is having the right consistency of paint and the timing.

MATERIALS + TOOLS

acrylic paint

water

plastic plate

paintbrush

surface

dishwasher rinse aid

hair dryer (optional)

paper towels or baby wipes

SURFACES

canvas

panel

watercolor paper

ARCHIVAL QUALITY

Excellent

TIPS

Experiment with different color combinations and slightly different viscosities of paint.

Spray a paper towel with some alcohol to remove more paint once it is dry.

Try dabbing on the rinse aid with a paintbrush or sponge.

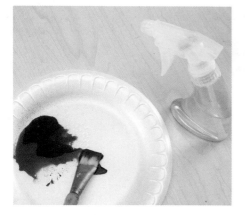

1 Thin the acrylic paint of your choice with water.

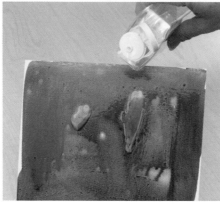

2 Using the paintbrush, apply a coat of the thinned paint to the surface. While the paint is wet, drop the rinse aid onto the surface. You can tilt the surface to make it run or keep the surface flat.

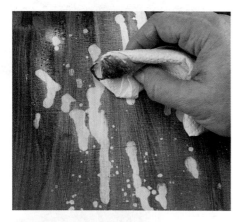

3 Let the paint dry, or dry it with a hair dryer. Using a damp paper towel or baby wipes, wipe off the rinse aid.

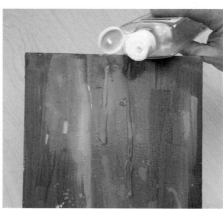

4 If desired, repeat using different colors.

VARIATIONS

A. Splatter: Use a fan brush dipped in the rinse aid to splatter dots, or an eyedropper. **B. Surprise:** Create a background of different pastes and colors and let it dry. Do the rinse aid technique over it and let it run, revealing all the layers and textures underneath. **C. Contrast:** Layer different colors for contrast. **D. Layers:** Use different backgrounds of collage or the Pulled Paper technique on page 50. **E. Fun:** Apply rinse aid with a foam stamp.

TROUBLESHOOTING

Paint consistency is very important for this technique. If the paint is too thick or too runny, it won't work.

If you wipe off the rinse aid before the paint is dry, you will lose the streaked effect; and if the paint is very wet, you'll likely wipe the paint off along with the rinse aid. Make sure the paint is dry before wiping.

If your paint is too thick, the rinse aid won't be able to penetrate it and sit on the surface of the paint. Allow the paint to dry, and then wipe off the rinse aid. You can use this painted surface as your new background and repeat the technique.

If you wait too long, and the rinse aid dries, spray glass cleaner onto the surface and immediately wipe it away with a paper towel.

RESIST | Salt

It is amazing how many art supplies you can find around the house. This is a simple technique that can you easily layer. It adds a speckled effect to an area, and it can soften the look of an image.

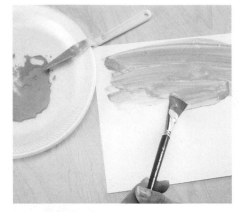

1 Paint the surface with paint diluted with water, about the consistency of 2 percent milk.

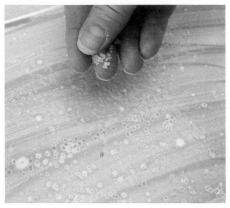

2 Sprinkle different sizes of salt on top of the wet paint.

3 After the paint is dry, use a paper towel to brush off the salt.

MATERIALS + TOOLS

paintbrush
acrylic paint or watercolors
water
surface
salt in different sizes
paper towel

SURFACES

canvas
panel
watercolor paper

ARCHIVAL QUALITY

Excellent

TIPS

Use table salt, sea salt and rock salt to create a variety of interesting patterns.

You will get a different look on porous versus slick surfaces.

TROUBLESHOOTING

Do not wait more than an hour or two to brush off the salt. Otherwise you may have a permanently gritty surface.

VARIATIONS

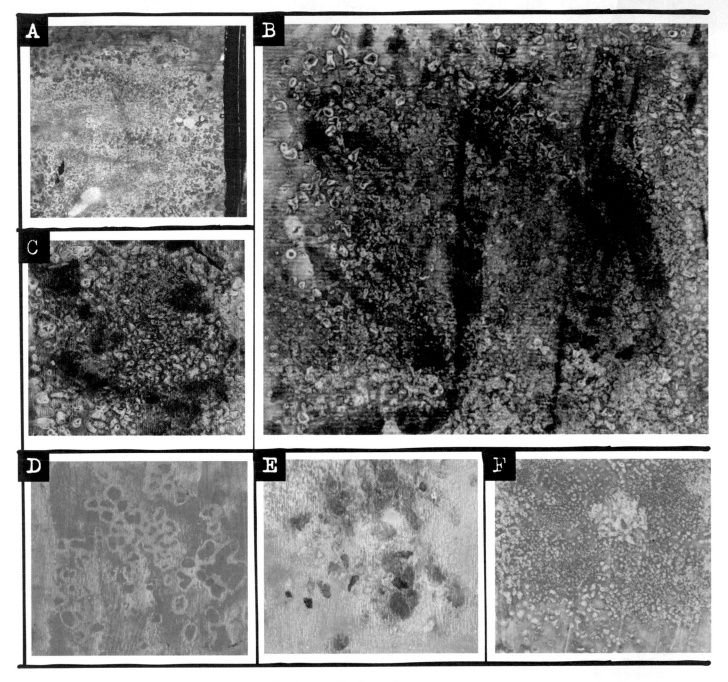

A. Metal Leaf: Use metal leaf as the surface background for art that really glows (see Metal Leaf on page 38). If you're using gold leaf, seal it before doing this technique or it will tarnish. **B. Layer:** Repeat this technique as many times as desired, using different colors. **C. Drama:** Paint the surface a dark color and allow it to dry. Use this technique with interference or metallic paint for dramatic results. **D. Bling:** Use metallic paint over a dark background. **E. Size Variation:** Different sizes of salt will make different sized spots. Kitty litter can even have an effect on the paint. **F. Dirty Salt:** You can reuse the salt from this technique; the residue paint will show up on the second salt resist.

 Soap

We love resist techniques because they produce unpredictable and unexpected results you can't recreate; and we love the fact that we already have soap in the studio.

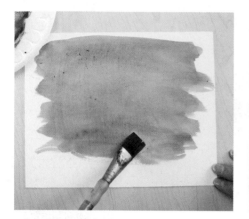

1 Using the paintbrush, paint the surface with fairly wet paint.

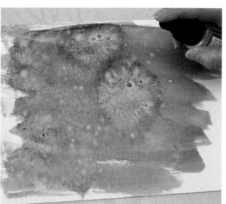

2 Spray or drop the soapy water onto the wet paint.

3 When the paint is dry but the soapy water drops are still wet, blot the surface with a paper towel. Let it dry and repeat with a different color if desired.

MATERIALS + TOOLS

paintbrush

acrylic paint or watercolors

surface

dish soap mixed with water in a spray bottle (about 1 teaspoon into 1 cup of water)

paper towel

SURFACES

canvas

panel

watercolor paper

ARCHIVAL QUALITY

Excellent

TIPS

Timing and paint consistency (viscosity) are the keys to success for this technique.

Spray soapy water into the air and catch the drops on your surface as it falls.

You will get a very different look on porous versus slick surfaces.

TROUBLESHOOTING

If the paint is not watered down, this technique will not work. If it doesn't work the first time, try changing the amount of water in your paint.

VARIATIONS

A. Bling: If your are doing this technique over painted metallic leaf, you will need to spray the leaf with a workable fixative and allow it to dry prior to painting. **B. Reinvent:** Use this technique over backgrounds or areas of old paintings. You may be inspired to work on a piece in which you've lost interest. **C. Drama:** Experiment with this technique using dark colors and interference paints. **D. Atmospheric:** A really wet paint sprayed with soapy water gives the look of a night sky. **E. Bubbles:** Mix some dish soap into the paint. The more you whisk the paint, the bigger the bubbles will become; the archival quality remains excellent.

RESIST | Water

This technique is similar to the soap resist, but you can preserve and see the underlying layers more clearly. Timing is everything in this technique, so keep playing with it and experimenting. This is a wonderful technique to help you learn how colors and layers can enhance your painting.

MATERIALS + TOOLS

paintbrush

acrylic paint or watercolors

surface

spray bottle of water

paper towel

SURFACES

canvas

panel

watercolor paper

ARCHIVAL QUALITY

Excellent

TIPS

Try different tools to apply water, like a toothbrush, fan brush or an eyedropper.

Try using different viscosities of paint, but don't let it get too thick or it will get messy.

Spray the water in the air and catch it on your surface as it falls for a micro-splatter effect.

Experiment with different drying times to see what effects they have.

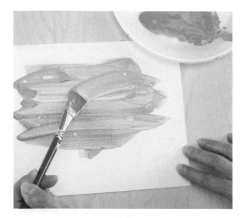

1 Paint the surface with fairly wet paint.

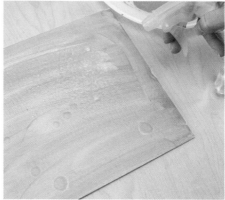

2 Spray or drop water onto the wet paint.

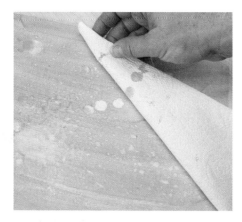

3 When the pant is dry, but the water drops are still wet, blot the surface with a paper towel.

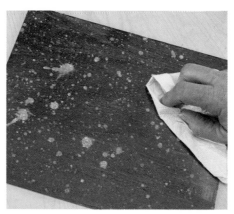

4 Repeat with a different color if desired.

TROUBLESHOOTING

If you don't see any reactions after spraying the surface with water, you probably let the paint get too dry prior to spraying. You can let the surface dry completely and then try the technique again. The mistake layer can be your base color.

If everything wipes off, you have not let the paint dry long enough. If you blot too soon, you can wipe everything off and start over.

Be sure to blot the surface, not rub or wipe off the water. Wiping or rubbing the water may smear the paint if it's not dry enough.

VARIATIONS

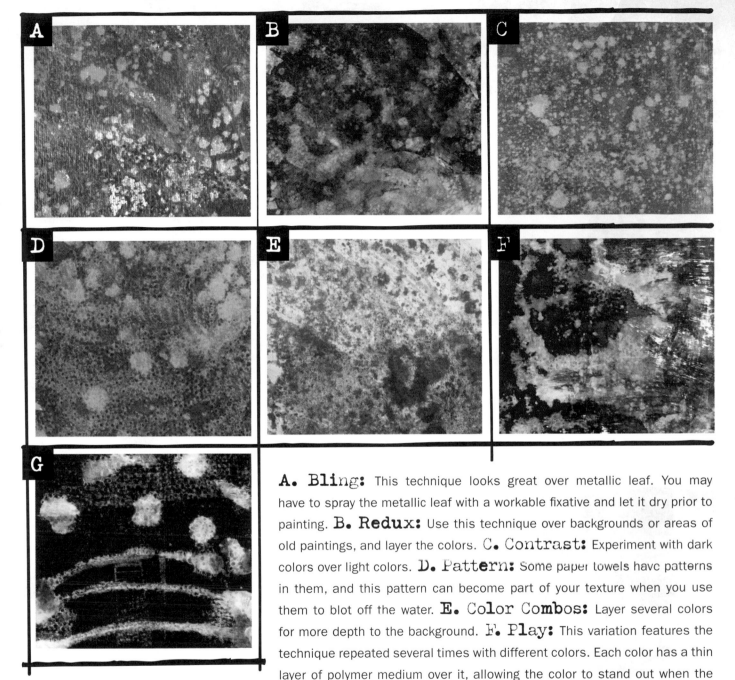

A. Bling: This technique looks great over metallic leaf. You may have to spray the metallic leaf with a workable fixative and let it dry prior to painting. **B. Redux:** Use this technique over backgrounds or areas of old paintings, and layer the colors. **C. Contrast:** Experiment with dark colors over light colors. **D. Pattern:** Some paper towels have patterns in them, and this pattern can become part of your texture when you use them to blot off the water. **E. Color Combos:** Layer several colors for more depth to the background. **F. Play:** This variation features the technique repeated several times with different colors. Each color has a thin layer of polymer medium over it, allowing the color to stand out when the piece is sanded. **G. Draw:** Use an eyedropper to draw with the water.

All-Purpose White Craft Glue

This is an easy technique for adding depth and a colored, crackled texture to a painting. The crackle can be layered, feathered or applied on top of other textures or metal leaf. It's a lot of fun to watch the crackle develop. We've found that the Elmer's brand glue works best, but feel free to experiment with different brands.

MATERIALS + TOOLS

paintbrushes

acrylic paint

surface

all-purpose white craft glue

hair dryer (optional)

SURFACES

canvas

panel

Plexiglas

watercolor paper

ARCHIVAL QUALITY

Good

TIPS

If you want to soften the cracks, use another clean brush with a little water to feather out the edges after you have applied the paint (see variation D).

Use a complementary color for real zing.

1 Paint or decorate the surface as desired, and allow it to dry. Using the paintbrush, apply a layer of all-purpose white craft glue on the surface with a brush; the thicker the layer, the bigger the cracks.

2 Using a clean, dry paintbrush, apply the paint onto the wet glue. The direction you apply the paint is the direction the cracks will be. Let the paint sit on the surface of the glue. Do not overwork the paint.

3 Let the glue and paint dry. As it dries, you will see the cracks appear. You can use a hair dryer on low to speed up the process, but keep it moving to prevent puddling.

TROUBLESHOOTING

If you use the same paintbrush for steps 1 and 2, the effect will be minimal. We recommend a new, clean paintbrush to apply the paint.

If you overwork the paint by repeatedly brushing over paint that is already applied to the glue, you will not achieve the crackle effect.

VARIATIONS

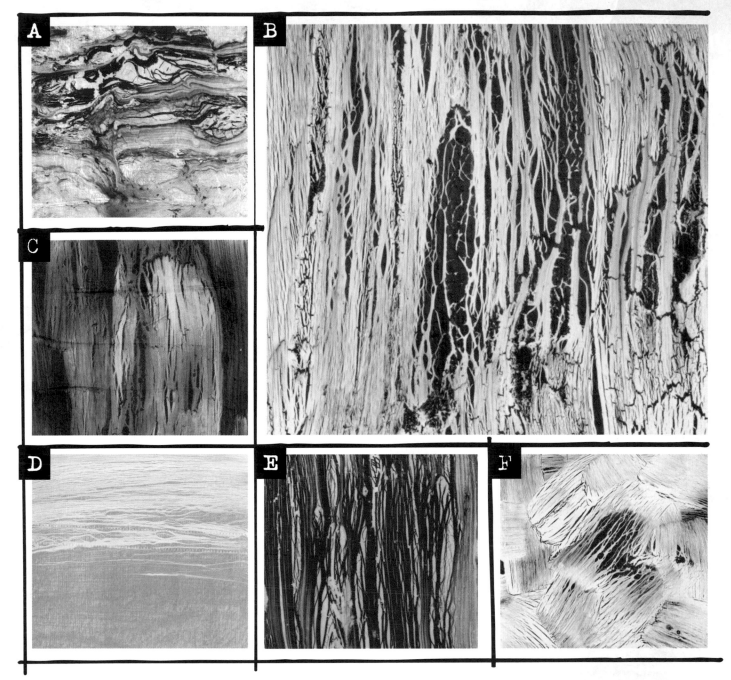

A. Spots: Sprinkle water after step 2 for a slightly different effect. Let the entire surface dry before continuing with the art. **B. Linear Design:** Apply the paint in only one direction. **C. Color:** Try this technique with an interference paint color on a dark background. **D. Gradient:** Blend out paint with a little water. **E. Drama:** Repeat this technique using complementary colors on the different layers. **F. Variety:** Apply the paint to the glue in different directions for lots of texture and interest.

Painted Leaf

This metallic-leaf technique leads to various patterns depending on the consistency of your paint. Play around with different thicknesses of paint to see which results you like best.

MATERIALS + TOOLS

paintbrush

metal-leaf adhesive

surface

scissors

wax paper

leaf-sealer spray or spray varnish

metal leaf

acrylic paint

water

SURFACES

canvas

panel

Plexiglas

watercolor paper

ARCHIVAL QUALITY

Excellent

TIPS

Consider painting a background color prior to putting leaf size and leaf on the surface so the color will show through any gaps in the leaf.

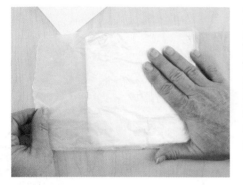

1 Using the paintbrush, apply the metal-leaf adhesive to the surface. Wait a few hours until the adhesive is tacky. Cut a piece of wax paper to approximately the size of the metal leaf. Place the wax paper on top of the leaf and gently rub. This will create static, and the leaf will stick to the wax paper, making it easier to handle.

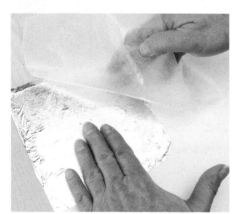

2 Pick up the wax paper; the metal leaf will be attached. Lay the leaf onto the surface, and rub it down with your hand. Pull off the wax paper. Repeat steps 1–2 until the background is covered.

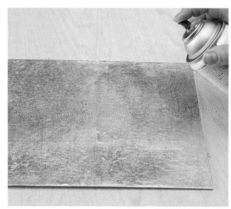

3 Spray the leaf with a sealing spray or a spray varnish. Allow the spray to dry.

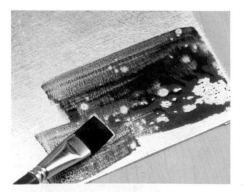

4 Mix the paint with water so it's thin. Using a flat paintbrush, paint the metal leaf. You may see it pool rather quickly; keep brushing back into the paint until it stays. When you are happy with the look of the paint, let the paint dry. You can now continue with your artwork as desired.

TROUBLESHOOTING

If your paint is too wet your stamp will be saturated. If it is too dry, you will get a poor result. You can try applying glazing medium as a means to extend drying time.

VARIATIONS

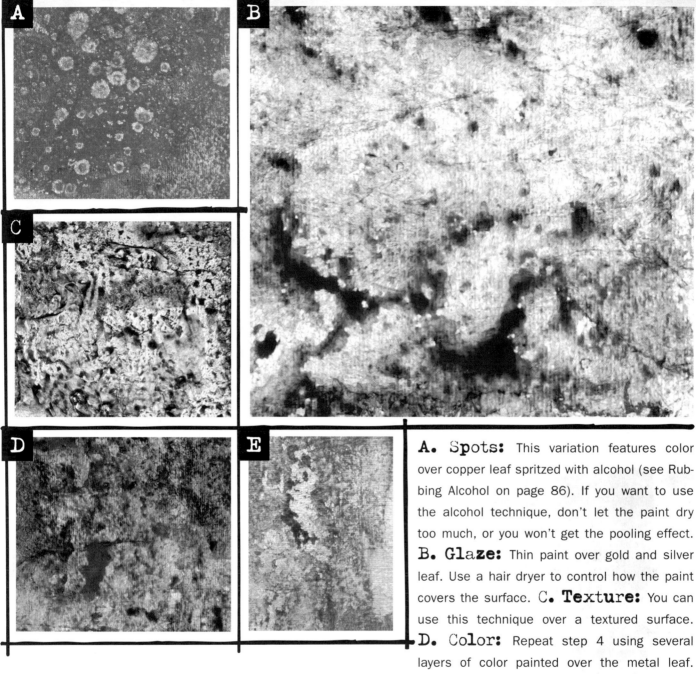

A. Spots: This variation features color over copper leaf spritzed with alcohol (see Rubbing Alcohol on page 86). If you want to use the alcohol technique, don't let the paint dry too much, or you won't get the pooling effect. **B. Glaze:** Thin paint over gold and silver leaf. Use a hair dryer to control how the paint covers the surface. **C. Texture:** You can use this technique over a textured surface. **D. Color:** Repeat step 4 using several layers of color painted over the metal leaf. **E. Drama:** Thicker paint doesn't pool as much, and it covers the leaf more.

TROUBLESHOOTING

If the paint won't adhere to the leaf, try using a hair dryer set on low as you brush the paint to control the paint flow and drying time. Or add more paint so it is thicker.

If you use gold leaf and it turns dark, you likely forgot to seal the leaf with the sealing or varnish spray. You'll have to start over if you want the original luster, so be sure to spray as instructed.

AFTERNOON BREAK
Darlene Olivia McElroy

Main technique: Salt (page 100)

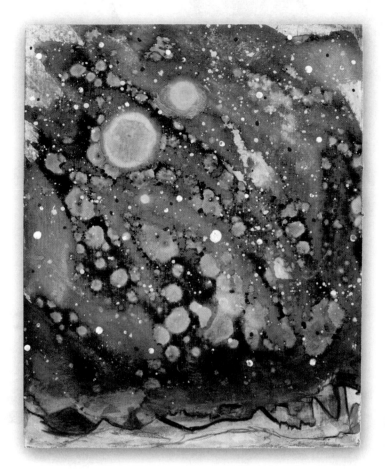

NEW MEXICO NIGHT
Sandra Duran Wilson

Main technique: Soap (page 102)

FORMULA TO THE SKIES
Sandra Duran Wilson

Main technique: Water (page 104)

REFLECTIONS
Darlene Olivia McElroy

Main technique: All-Purpose White Craft Glue (page 106)

NEW MEXICO JOURNEY
Sandra Duran Wilson

Main technique: Painted Leaf (page 108)

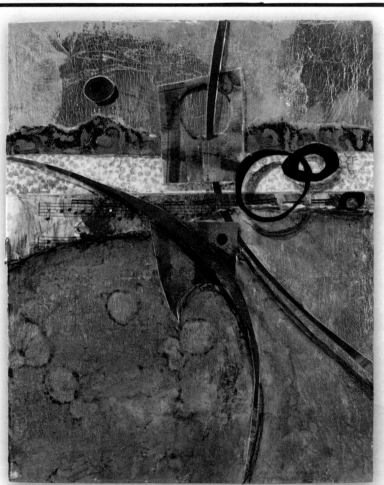

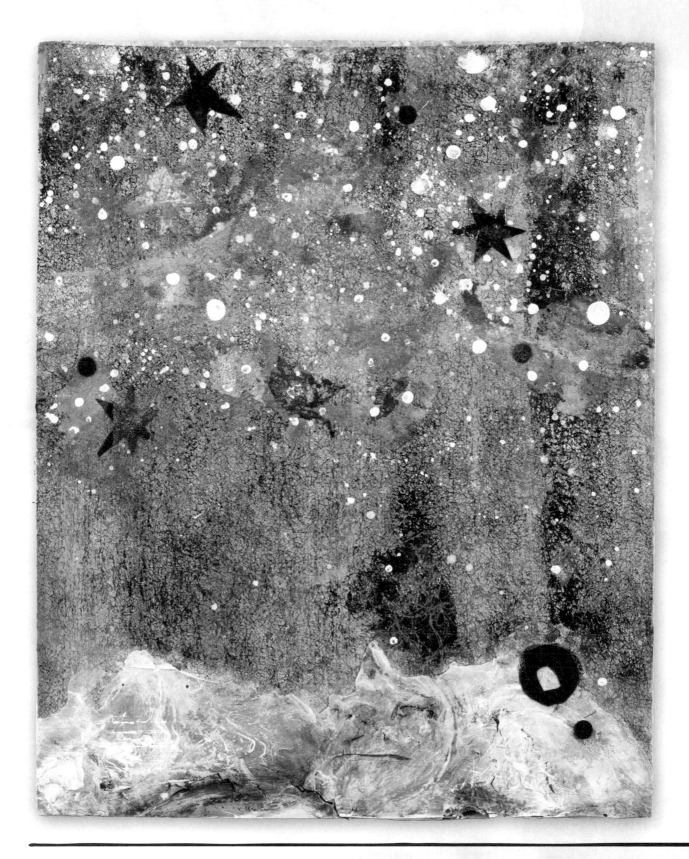

MILKY WAY
Sandra Duran Wilson

Main technique: Fusible Webbing (page 114)

Fusible Webbing

Fusible webbing is sold under several names, such as Wonder Under and Bondaweb, and it comes in different weights. It is used to join fabrics together using heat, but you can use it for wonderful texture—and another way to layer paint and attach papers, foil or fabrics to your art.

1 Use a dry paintbrush to apply a thin layer of black paint over the entire surface of the fusible webbing. Apply heavier brushstrokes in some areas. Let it dry.

2 Paint another fusible webbing surface with acrylic paints thinned with water. The water will help separate the fusible webbing from its paper backing. Let the paint dry and then remove the fusible webbing from the backing paper.

3 If desired, paint the surface and allow it to dry. Place the painted webbing on the surface. Lay a piece of the parchment paper over it and iron with a medium-heat dry iron, pressing down for about 20 seconds to secure the bond. Let the surface cool, and pull off the parchment. If the bond is not secure, place the parchment paper back down and heat some more.

MATERIALS + TOOLS

paintbrush

acrylic paint

fusible webbing

water

surface

ironing board or other heat-resistant surface

parchment paper

iron

SURFACES

aluminum foil

canvas (must be able to iron onto it, so it can't be stretched)

metal

panel

watercolor paper

ARCHIVAL QUALITY

Good

TIPS

Parchment paper is easy to see through when ironing, so you can see what you are bonding.

You can heat the web with a heat gun to make holes in the webbing and create a distressed look.

TROUBLESHOOTING

Always use a dry iron—no steam—for this technique. Steam will only make the webbing and paint gummy.

Try different heat settings, depending on your surface. For example, if you are ironing onto a thin or fragile fabric, use a cooler setting and press down for less time. If you are ironing onto heavy metal, you may need to increase the heat or time.

Always use a clean piece of parchment paper for ironing, and do not use the backing you painted on. If you iron using the painted backing, it may stick to the surface.

VARIATIONS

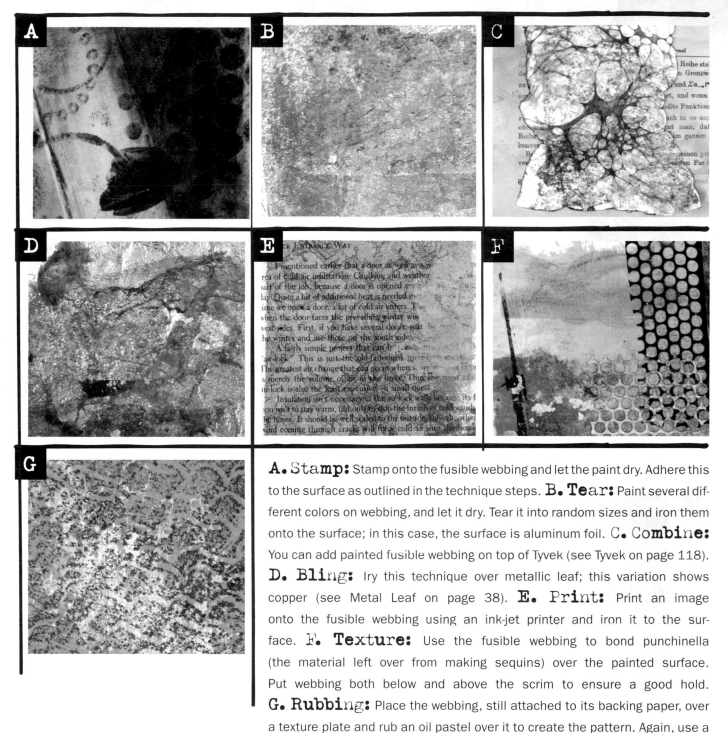

A. Stamp: Stamp onto the fusible webbing and let the paint dry. Adhere this to the surface as outlined in the technique steps. B. Tear: Paint several different colors on webbing, and let it dry. Tear it into random sizes and iron them onto the surface; in this case, the surface is aluminum foil. C. Combine: You can add painted fusible webbing on top of Tyvek (see Tyvek on page 118). D. Bling: Iry this technique over metallic leaf; this variation shows copper (see Metal Leaf on page 38). E. Print: Print an image onto the fusible webbing using an ink-jet printer and iron it to the surface. F. Texture: Use the fusible webbing to bond punchinella (the material left over from making sequins) over the painted surface. Put webbing both below and above the scrim to ensure a good hold. G. Rubbing: Place the webbing, still attached to its backing paper, over a texture plate and rub an oil pastel over it to create the pattern. Again, use a piece of parchment paper when ironing the fusible webbing to the surface.

SUBTRACTIVE OR COMBINATION
Rust

You can rust anything, from seashells to embossed wallpaper to artificial flowers. It is so much fun to watch the magic as your art rusts. The more texture you have, the more drama will result.

MATERIALS + TOOLS

paintbrush

acrylic paint or watercolors

surface

two-part rusting compound

SURFACES*

canvas

fabrics

objects

panel

watercolor paper

ARCHIVAL QUALITY

Excellent

TIPS

Do not use the same brush for both parts of the compound, or you will get a rusty brush.

To eliminate contrasting surface color showing through, paint the surface dark gray or burnt umber.

* You can use this technique on just about any surface. We recommend testing it on a small patch before committing to working on an entire surface.

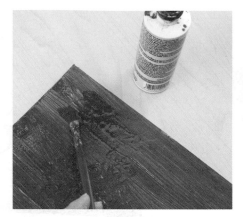

1 Prepare the surface as desired and allow it to dry. Using a clean paintbrush, paint the surface with the iron part of the two-part compound. Let it dry thoroughly. Clean the paintbrush immediately.

2 With a clean paintbrush, apply the rusting agent.

3 It can take an hour or more for the change in appearance to show. A second coat may be applied at any time if the effect is not working as well as you want.

TROUBLESHOOTING

If your piece is not rusting, it's usually because not enough of one of the two compounds was applied. Just add more.

VARIATIONS

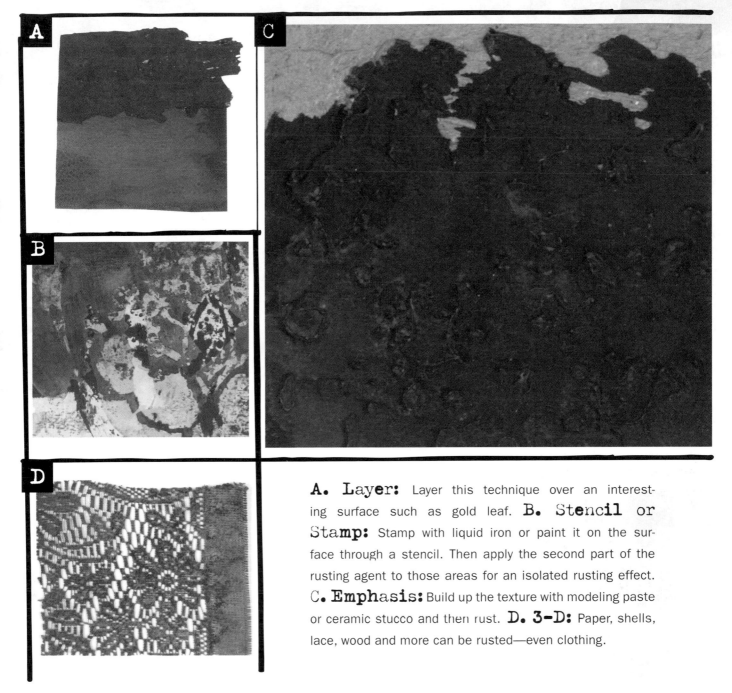

A. Layer: Layer this technique over an interesting surface such as gold leaf. **B. Stencil or Stamp:** Stamp with liquid iron or paint it on the surface through a stencil. Then apply the second part of the rusting agent to those areas for an isolated rusting effect. **C. Emphasis:** Build up the texture with modeling paste or ceramic stucco and then rust. **D. 3-D:** Paper, shells, lace, wood and more can be rusted—even clothing.

Tyvek

Tyvek is a spun olefin product made by DuPont. It is used for many things like shipping envelopes, building houses and arts and crafts. You can purchase Tyvek in sheets (see Resources on page 142), or you can use recycled Priority Mail envelopes. Tyvek is impervious to the elements except for heat, and that is what we use to get it to react. Important: Heating synthetic fibers produces fumes, so do this only outside.

MATERIALS + TOOLS

scissors

Tyvek

iron (no steam)

ironing board or towel

parchment paper

adhesive

surface

SURFACES

Tyvek can be applied to most surfaces by gluing or sewing it on; do not use heat-related adhesives.

ARCHIVAL QUALITY

Unknown: If the Tyvek is encased in paint and not exposed to the elements, it should be OK.

1 Cut the Tyvek larger than the desired size. Set up the iron in a well-ventilated area (preferably outside). Use an ironing board or lay a towel over a heat-resistant surface. Place the Tyvek between a folded sheet of parchment paper.

2 Apply the heated iron (no steam) gently to the parchment paper. Start at a low temperature and increase as needed. Lightly hold the iron over the surface in one area; the Tyvek will suddenly shrink when it gets hot enough.

3 If you stop at this point, the sheet will be crumpled.

TIPS

Experiment with the temperature and the amount of pressure you apply to the Tyvek while heating it with the iron.

Tyvek reacts differently depending on which side you apply the heat. Concave bubbles will result if you apply the heat to the painted side, and convex bubbles will occur if you apply the heat to the unpainted side.

The paint acts as a barrier to the iron. Areas that have thick paint will not react as much as areas with washes or thin paint.

For alternative fabrics, try cheap polyester fabric and cheap craft felt.

You can also use a heat gun, but you will have less control.

If you cut the Tyvek into a shape, it will retain that shape during heating.

4 Move the iron to a different area. As you heat it more, the Tyvek will shrink and buckle. Bubbles will form. When you are satisfied with the results, turn off the iron and allow the Tyvek to cool before incorporating it into the artwork. You can use most adhesives to adhere the Tyvek to your artwork, but do not use any heat-related adhesives.

TROUBLESHOOTING

The Tyvek will shrink considerably, so start with a larger piece than needed.

Watch the Tyvek while heating because it will shrink quickly. You should be able to see the Tyvek beneath the parchment sheet. Keep an eye on it so it doesn't disappear.

The Tyvek from envelopes reacts faster to the heat than the Tyvek sheets do.

VARIATIONS

A. In and Out: This variation shows concave (left) and convex (right) bubbles. **B. Yin and Yang:** This variations show Tyvek painted on both sides. Apply acrylic or fabric paints, felt markers, dyes, colored pencils or watercolors to decorate the Tyvek. **C. Heavy:** Apply thick paint in a striped pattern. **D. Shape:** Place Tyvek directly over a rubber stamp (do not use foam stamps). Place parchment paper over the Tyvek, and heat. The Tyvek will melt into the shape carved on the stamp. **E. Naked:** Tyvek that is not decorated with paint is stark white. **F. Demented:** Keep heating until the Tyvek breaks down.

SUBTRACTIVE OR COMBINATION
Patinas

Age your art, sculpture or almost any object with patinas. They come in copper or bronze surfacers, and the aging solution can be green, blue, black or blond.

1 Embellish the surface as desired, and allow it to dry. Using the paintbrush or palette knife, apply the patina surfacer to the surface.

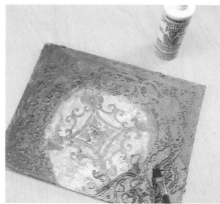

2 When the patina surfacer is dry or damp, apply the aging solution with either a spray bottle or a clean paintbrush.

3 It can take half an hour to an hour or more for the aging to appear. You can add more aging solution any time.

MATERIALS + TOOLS

paintbrush

acrylic paint

surface

palette knife

patina two-part solution (copper or bronze)

spray bottle (optional)

SURFACES

canvas

embossed paper

panel

paper paste

objects

watercolor paper

ARCHIVAL QUALITY

Good

TIPS

The more texture on the surface, the better the patina looks. Try stenciling or embedding objects for more texture. The aging solution will work whether the patina surfacer is dry or damp.

There is no need to seal the patinas. However, you may decide to seal other elements of your artwork.

TROUBLESHOOTING

If your patina isn't showing up, you don't have enough patina surfacer or not enough aging solution. Add more patina surfacer and try again.

VARIATIONS

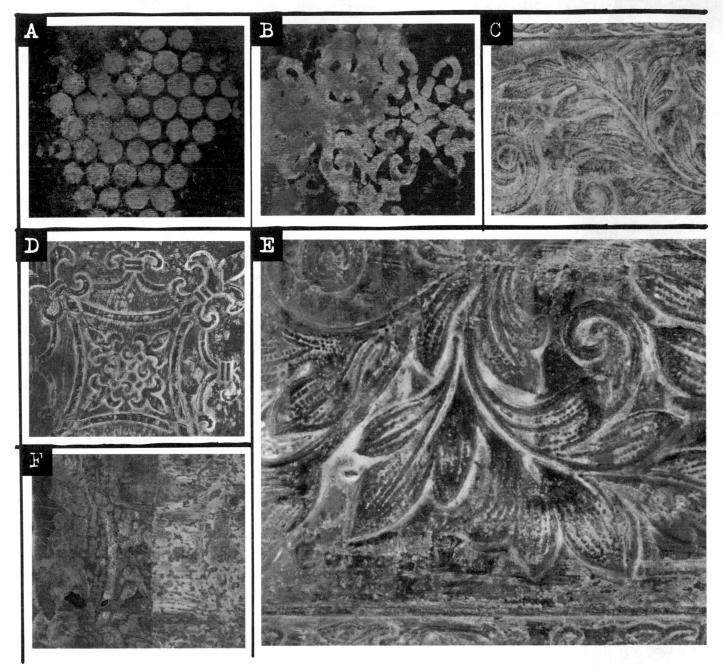

A. Stamp: Apply the surfacer onto the textured surface and then stamp on the surface. When it's dry, apply the aging solution. **B. Stencil:** Apply the surfacer through a stencil onto the surface. When it's dry, apply the aging solution. **C. Wash:** Apply the surfacer to a heavily textured surface. Add a color wash on top of the dry surfacer, and then spritz on the aging solution. **D. Combinations:** Try mixing patinas or combining flat areas with stencil areas. **E. Drama:** Use embossed paper, lace or a heavily textured surface to get the most impact with your patina. **F. Dry Brush:** After you have the desired amount of patina and it is dry, use a dry paintbrush to paint over the raised surfaces to highlight the texture.

Scribing

Here's your chance to put your personal mark on your art. The variety of marks you can make is as endless as the tools you use and adds interest to your surface, so start scratching and scraping. Use it as your preliminary layer or top layer.

1 Paint the surface a base color, and allow it to dry. Add layer of another paint color.

2 Using the mark-making tools, scribe into the wet paint. When you are satisfied with the design, lct the paint dry before continuing with the art.

MATERIALS + TOOLS

paintbrush

acrylic paint

surface

mark-making tools

SURFACES

canvas

panel

Plexiglas

watercolor paper

ARCHIVAL QUALITY

Excellent

TIPS

Before laying down your paint, remember that the base color will show through and choose accordingly.

An isolation coat of polymer medium will make your marks much crisper.

Rubber brushes are ideal marking-making tools for this technique.

TROUBLESHOOTING

If paint is too wet, the marks will fill in. If paint is too dry, it is more difficult to make clear marks.

VARIATIONS

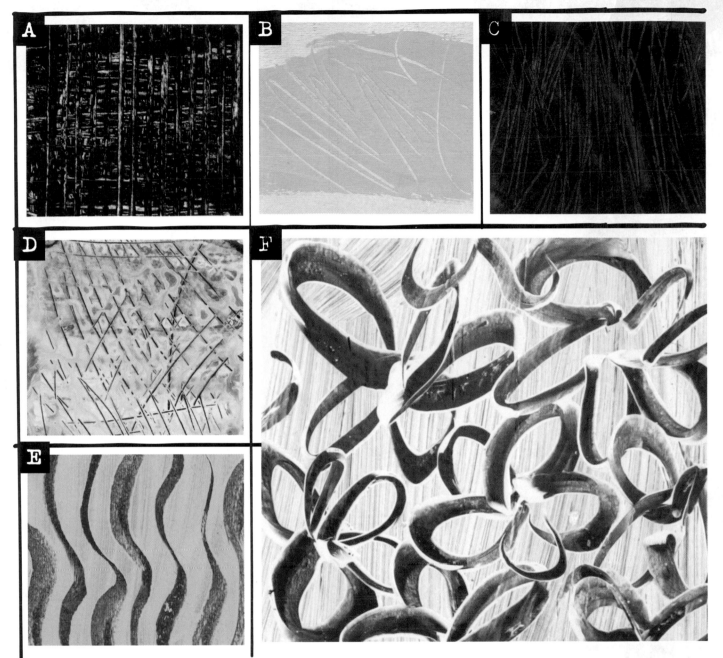

A. Texture: Scrape into thick paint for thick and thin areas. **B. Write:** Scribe a message in your art; make it meaningful or nonsensical, legible or not—either way, it will add some mystery. **C. Scratch:** Use marking tools like pencils and twigs to mark the wet paint. Scratches will show the bottom color just a little. **D. Marks:** Use large marking tools like forks and rubber brushes to reveal the bottom color. **E. Drama:** The bottom color will always show through, so try dramatic color combinations. **F. Draw:** We like using chiseled rubber brushes to draw designs and images into the paint. It's more planned than scratches and marks, and it can play a larger role in the art.

SUBTRACTIVE OR COMBINATION
Sanding

Age your art by sanding the decorated surface. It takes your work to a different place, mimicking old frescoes or signs. Play around with different kinds of sandpaper to get a feel you like.

MATERIALS + TOOLS

paintbrush

acrylic paint

surface

sandpapers with different grits

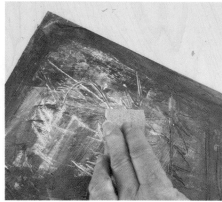

1 Prepare the background as desired, and allow it to dry. Use the paintbrush to apply a layer of paint; allow it to dry. You can apply several different colors of paint, allowing each to dry.

2 Sand until the underneath layer shows. Start with finer-grit sandpaper; work up to coarser sandpaper if you want more paint to show through. Remove any dust from the surface before continuing.

 You may want to do your sanding outside to avoid inhaling fine particles.

SURFACES

canvas

objects

panel

watercolor paper

ARCHIVAL QUALITY

Great

TIPS

Textured surfaces will show up in the sanding process best, so use the texture strategically in your design.

TROUBLESHOOTING

If the layer below isn't showing through well, start the technique over and an isolation coat of soft gel between each layer of color. Doing so allows for more of the underneath layer to show.

 If you desire a clear image when sanding all the way to the surface, try either lightly sanding with finer grit or add an isolation coat between the colors.

VARIATIONS

A. Paraffin: If you want to protect the decorated surface, rub paraffin over the surface before painting. The more paraffin you use, the more the image will show through when you sand off the paint layered over it. You'll be left with a pleasant, weathered paint appearance. **B. Layer:** On a textured surface, layer paint colors, letting each layer dry between applications. Gently sand to see through to all colors. **C. Stamping:** Stamp a design or text on the surface. Brush on a layer of soft gel and allow it to dry before adding the layer of paint. When sanding, the isolation coat will protect the stamping. **D. Image Transfers:** Apply an image transfer on the painted surface. When it's dry, use sandpaper it to age it. If you place the image transfer over a textured surface, you'll get very interesting results. **E. Stains:** Stain a scribed, gessoed surface with diluted paint. Let it dry and then sand.

SUBTRACTIVE OR COMBINATION
Crazy-Easy Transfer Painting

This technique is one of our favorites! Imagine making a monoprint with almost no cleanup; without using a press; using canvas, panel, paper, Plexiglas or metal; and with no size limit! Almost any of the additive techniques in this book can be done as a transfer painting. This technique is great for creating layers, drawing, stamping, cutting into shapes and lots more. It is similar to a monoprint in that whatever you do will be reversed.

MATERIALS + TOOLS

paintbrush

acrylic paint

clear polypropylene tarp/painter's drop cloth or plastic page sleeves

surface

paper towel polymer medium or polymer soft gel

SURFACES

canvas

metal

panel

paper

Plexiglas

ARCHIVAL QUALITY

Excellent

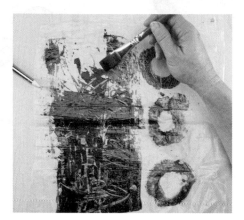

1 Using the acrylic paint, decorate the polypropylene tarp and let it dry.

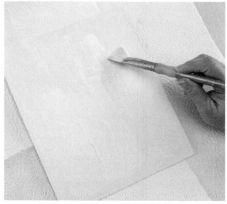

2 If desired, decorate the surface and let it dry thoroughly. Lay a few paper towels down to protect your work surface. Brush polymer medium on the surface.

TIPS

When using canvas as your surface, use soft gel as the medium for better adhesion.

If you use paper as your surface, use matte medium so the transfer method doesn't show.

Drying time varies depending on the absorbency of the surface. For example, it will dry faster on paper than on metal.

If you want to paint something specific, lay the tarp over the sketch and paint on the tarp's top. The image will be reversed when it is applied to the surface.

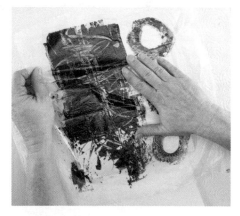

3 While the medium is still wet, lay the tarp, paint side down, on the surface. Use your hand to smooth it out.

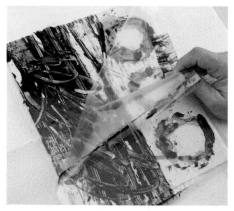

4 Let the polymer medium dry thoroughly; you may have to wait overnight. Gently peel off the tarp. The paint is now transferred to the surface.

VARIATIONS

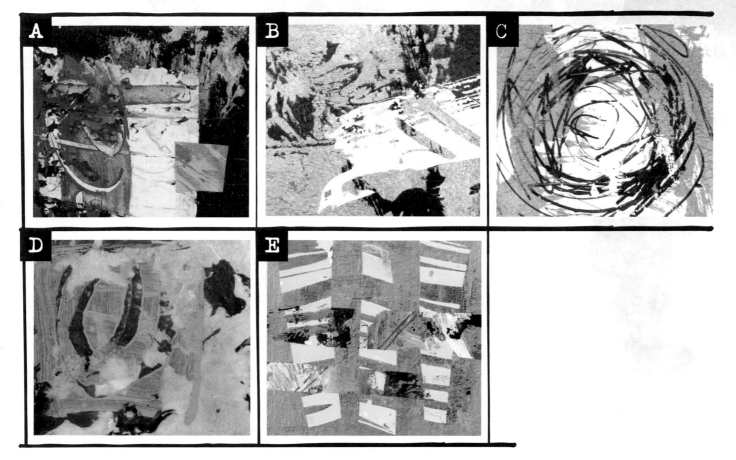

A. Layer: Repeat the technique after the first transfer is completely dry for an incredible layer effect. **B. Metal Leaf:** You can use this technique over a metal-leaf surface (see Metal Leaf on page 38) or add the metal leaf when painting the tarp. **C. Draw:** Use a permanent marker to draw on the tarp; it will transfer just as the paint does. **D. Create:** Paint an image or design, keeping in mind that it will be reversed. The image can become more central to the overall design of the artwork, so plan it carefully. **E. Cut:** With scissors, cut the painted tarp into shapes and follow steps 2–4.

TROUBLESHOOTING

If the image hasn't transferred, the most common reasons are you didn't use enough medium in step 2, you didn't let the medium dry thoroughly, you didn't rub it down well enough, or you put the tarp down on the wrong side. (Make sure it is paint side down.)

If the paint is sticky and not transferring well, lay the tarp back onto the surface and let the medium dry more. We suggest lifting only a corner of the tarp to check the medium's drying progress; it also makes laying the tarp back down easier.

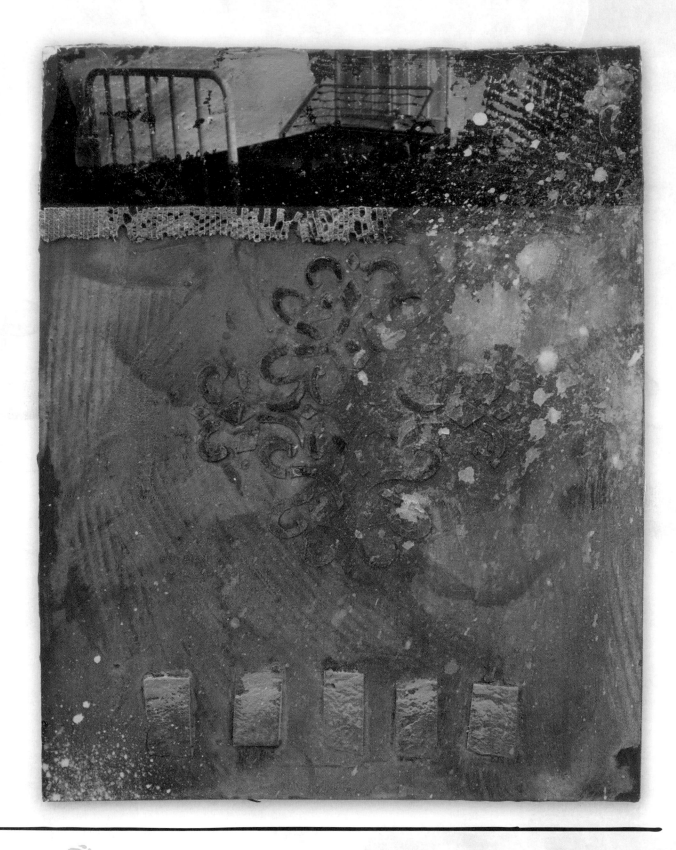

LONG GONE
Darlene Olivia McElroy

Main technique: Rust (page 116)

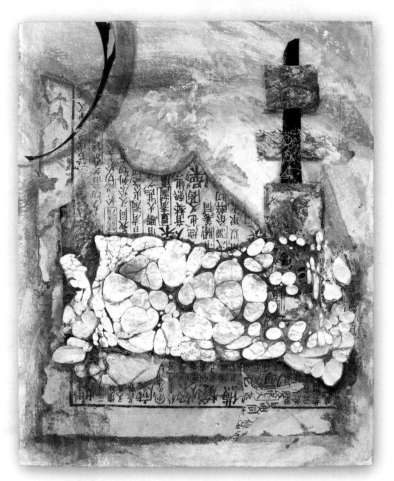

THE JOURNEY
Sandra Duran Wilson

Main technique: Tyvek (page 118)

FOU FOU FLOWERS
Darlene Olivia McElroy

Main technique: Patinas (page 120)

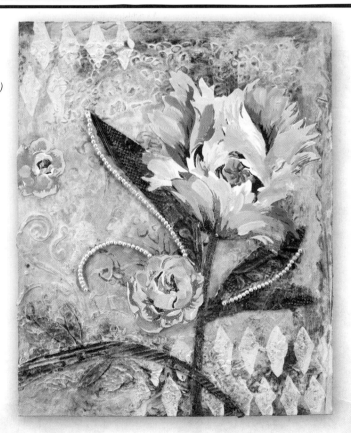

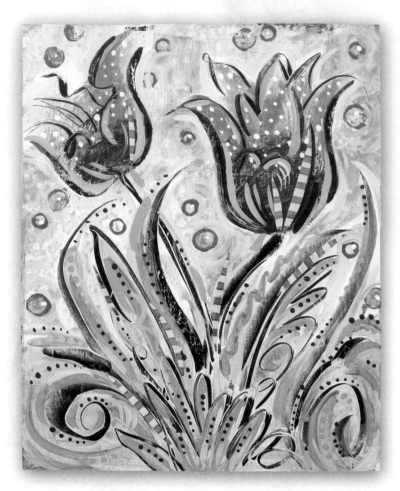

TULIPS
Darlene Olivia McElroy

Main technique: Scribing (page 122)

SHOW TIME
Darlene Olivia McElroy

Main technique: Sanding (page 124)

CALMING CHAOS
Darlene Olivia McElroy

Main technique: Crazy-Easy Transfer
Printing (page 126)

Inspirational Projects

By combining different surface treatments and even adding image transfers, you can create sophisticated surfaces and fun finished art. This section features artwork we've created by combining several techniques. To demonstrate how diverse these techniques can be, each artist used the same techniques to create the following paintings. We hope these projects give you a starting point to combine your favorite techniques and inspire you to come up with your own combinations.

What You'll Discover: We Are Very Different in Our Artistic Styles

Darlene is more representational. Her background as an illustrator lends itself to her storyteller style. She loves to be spontaneous and daring in her applications. She will break the rules and try new technique combinations, and this lends itself to wonderful discoveries. Darlene loves to rust things. Sandra often jokes that if anything stayed in place long enough, Darlene would rust it. She also employs a lot of stamps and stencils in her work; anything can become a stamp or a stencil—torn pieces of wallpaper, bubble wrap and corrugated coffee sleeves all find their way into her mixed-media paintings and sculptures.

Sandra loves to experiment, too, but her approach is more systematic and scientific. She has a science and printmaking background, and her abstract work is inspired by concepts such as quantum physics, optics, acoustics and astronomy. She loves to make acrylic paint act like wax, oil paints and watercolors. Her work has many layers of glaze, paint and medium—sometimes as many as twenty—and she loves to use metallic leaf and collage. Sandra loves the versatility of the techniques in this book, often creating the techniques on paper and then tearing them up and collaging them into her art. She especially likes resist techniques and will combine several of them in separate layers.

MATERIALS + TOOLS

plastic wrap

acrylic paint in ochre, pyrole red, buff, black, turquoise, blue and white

surface

putty knife

paintbrushes

stamps

image

water-slide transfer

scissors

paper towels

tray of warm water

polymer medium

sandpaper (optional)

ribbon

TECHNIQUES

Plastic Wrap

Stamping

Crazy-Easy Transfer Painting

Skins

She Was a Pushover for Fashion

By Darlene Olivia McElroy

Energy in a piece is always important to me and can be achieved through color movement, texture or, as in this case, by tilting the figure. I always have a primary and a secondary story in my pieces—they may be visual or color stories. This piece came from the feeling that I was in a fashion stalemate and needed to get out of my Einstein style of dressing—hence the highly decorated dress. The simplicity in my personal style allows me to get into the "more is more" layering of texture in my art.

1 For the background, use the Plastic Wrap technique (page 92) with the ochre paint.

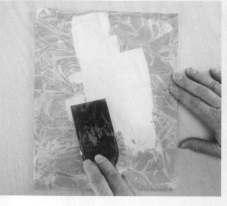

2 Using the large putty knife, scrape the buff acrylic paint in the area you want to place the water-slide decal. Allow the paint to dry.

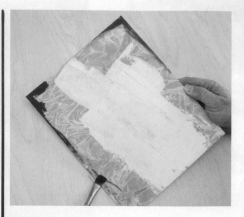

3 Paint the edges black with a paintbrush. Let the paint dry.

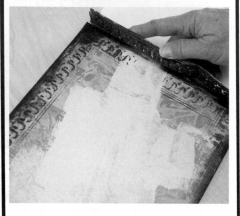

4 Paint the pyrole red onto the stamp (in this case, I'm using a textured wallpaper as a stamp). Stamp around the edges of the background (see Stamping on page 12). Allow the paint to dry.

5 Print the desired image onto the water-slide decal paper according to the manufacturer's directions. If your image does not cover all of the water-slide decal paper, use the scissors to trim off the larger white spaces.

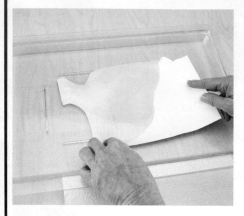

6 Put paper towels next to the tray of warm water. With the image face down, soak the water slide decal paper in the tray of water. After about a minute, when the decal begins to slide, carefully remove the decal from the tray and lay it face up on a paper towel. Gently blot the decal paper with the paper towels.

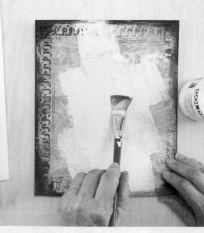

7 While the decal dries a little, use a paintbrush to quickly apply the polymer medium over the area on which you want to place the decal.

8 Lay the decal onto the polymer medium and gently slide out the backing paper.

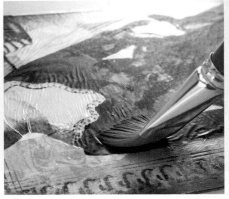

9 Use the paintbrush that has the polymer medium on it to brush over the surface of the decal, pushing any air bubbles out from under the surface. It's best to work from the center of the image out to the edges. Allow the decal to dry completely.

If needed, use the scissors to trim any of the decal that hangs over the edge of the surface, or you can use a fine-grit sandpaper to lightly sand them off.

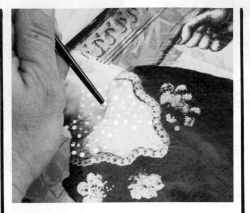

10 Stamp the flower design onto the image using the turquoise paint (see Stamping on page 12). Using the end of a small paintbrush and white paint, add polka dots to the neckline of the image.

11 Use the buff paint to make a Crazy-Easy Transfer Painting (see page 126). Cut the transfer as desired, and use a paintbrush and the polymer medium to adhere the pieces to the surface. Use the scissors to trim any of the transfer painting that hangs off the edge. Let the polymer medium dry thoroughly and then pull off the plastic to leave the paint.

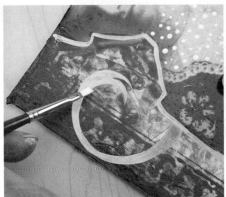

12 With buff paint, outline the image of the girl as desired, and add a ribbon to the background. Use the blue paint to highlight the ribbon. Let the paint dry.

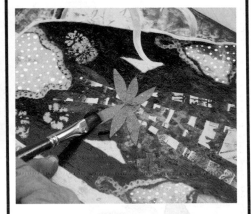

13 Make a skin, embellishing it with paint as desired (see Skins on page 46). With scissors, cut the skin as desired. Use the paintbrush and polymer medium to adhere it to the image. Let the polymer medium dry. Continue to embellish the art as desired. I added more polka dots to the sleeves to help balance the art.

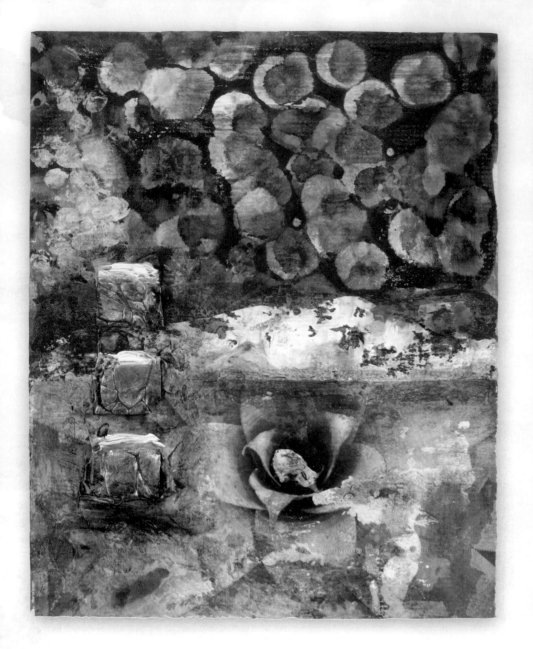

MATERIALS + TOOLS

acrylic paint in white, orange, cobalt teal, magenta, yellow-green, yellow and violet

2 panels

eyedropper

spray bottle of rubbing alcohol

paintbrushes

plastic wrap

water-slide transfer image

scissors

paper towels

tray of warm water

polymer medium

oil-based varnish

sandpaper (optional)

bubble wrap

Tyvek

soft gel (gloss)

spray varnish

TECHNIQUES

Rubbing Alcohol

Plastic Wrap

Crazy-Easy Transfer Painting

Stamping

Tyvek

Garden Party

By Sandra Duran Wilson

I love gardening, and when I travel, I always visit botanical gardens. When I look at plants under a microscope, I see a whole different world. The colors blend, and shapes take on new forms. This is my version of a landscape seen both with the eye and under a microscope. I like the unpredictable variations that are possible with layering the Rubbing Alcohol and Plastic Wrap techniques. The Stamping and Crazy-Easy Transfer Painting add rich layers. I adhered the Tyvek on top of the water-slide decal for even more texture. It adds the physical texture I often feel in the plants.

136

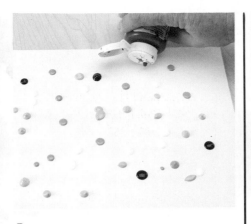

1 Place random drops of the cobalt teal, white, yellow-green and magenta paints onto one of the surfaces.

2 Place the other surface on top of the paint surface, and press them together while twisting them.

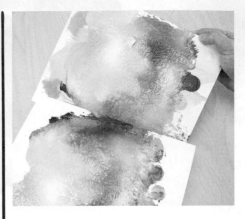

3 Pull the surfaces apart and let them dry.

Repeat steps 2–3 until you reach the desired effect.

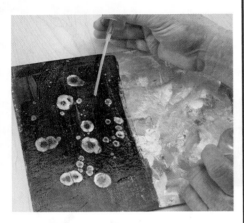

4 Choose 1 of the 2 surfaces you like best. Paint half of the surface with a magenta-violet mix of paint, and apply the Rubbing Alcohol technique (see Rubbing Alcohol on page 86).

5 In the middle of the surface, paint a horizontal band of yellow, and let it dry. Over the yellow paint, apply the Plastic Wrap with orange paint (see Plastic Wrap on page 92).

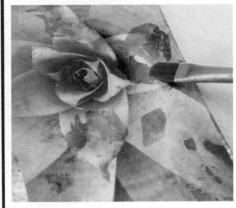

6 Prepare a water-slide transfer and add it to the artwork (see steps 5–9 on pages 134–135). Using the oil-based varnish, paint and dribble it over the transfer to make it transparent. Let it dry.

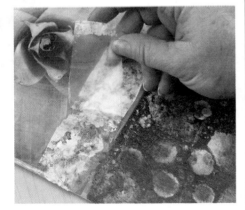

7 Prepare a Crazy-Easy Transfer Painting (see page 126). Cut it into strips to cover part of the orange and white band. Put polymer medium down, place the plastic paint side down and smooth the surface. Let it dry, and then pull off the plastic.

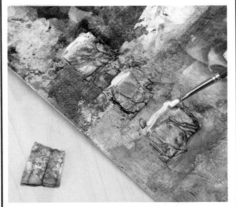

8 Stamp a corner of the image with bubble wrap and cobalt teal paint (see Stamping on page 12). Make a painted Tyvek piece (see Tyvek on page 118). Use the scissors to cut it into squares and then adhere them to the surface using the soft gel and a clean paintbrush. Let the soft gel dry thoroughly.

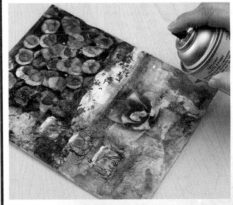

9 Use the various acrylic paints to embellish the artwork. Let the paint dry. Spray the artwork with the spray varnish to seal it.

137

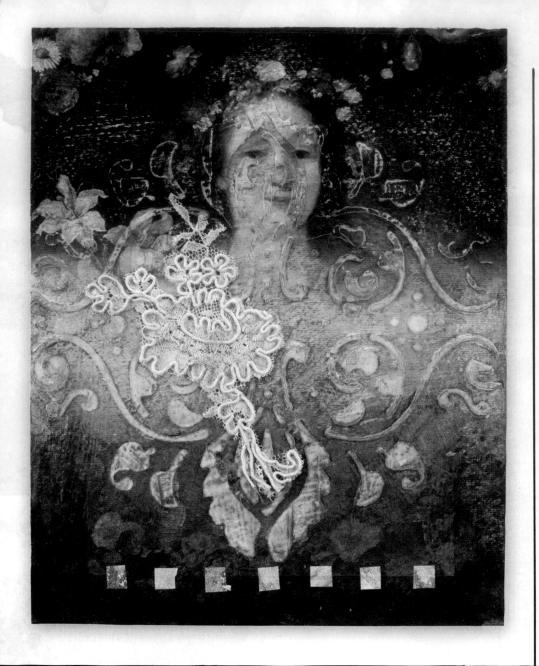

MATERIALS + TOOLS

paintbrushes

acrylic paint in brown, ochre, burnt umber, buff and gold

surface

stencil

clear gel medium, soft or hard

paper towel

sandpaper

water-slide transfer

image

scissors

tray of warm water

polymer medium

lace

spray varnish

TECHNIQUES

Stencil

Rubbing Alcohol

Sanding

Skins

Echoes of Her

By Darlene Olivia McElroy

I love imperfect and distressed surfaces. Stencils allow me to push this love by placing images over them and then sanding the image back where the stencil is. I also love the adventure of each art project. I never know where I am going—I just want to have fun getting there. If I make a wrong turn, I just throw more paint on. I channel the past into almost all my art, taking it to a more contemporary level. Think of the once-colorful Mayan temples that are the color of stone in our time: How would we paint them today?

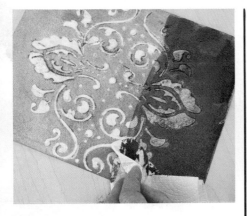

1 Paint the background with brown and ochre paints. Let the paint dry. Apply clear soft or hard gel through the stencil (see Stencil on page 14). Apply the burnt umber paint, and then rub off the excess.

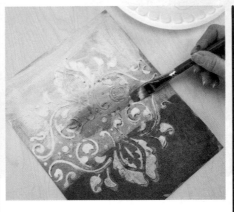

2 Paint and blend buff and gold on the top part.

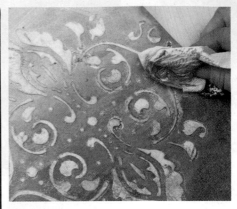

3 Wipe the excess paint off.

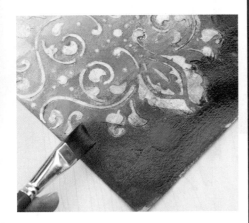

4 Add more burnt umber paint with the Rubbing Alcohol technique on the bottom part (see Rubbing Alcohol on page 86).

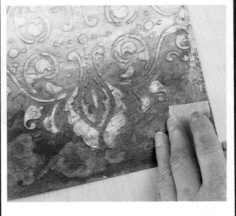

5 When it's dry, sand it back (see Sanding on page 124).

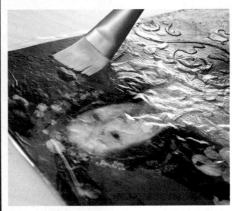

6 Apply a water-slide transfer on the top section of the background (see steps 5–9 on pages 134–135).

7 After the water-slide transfer has dried, sand back the decal to age the image and show more stencil.

8 Paint a slight border of burnt umber along the bottom edges. Let it dry.

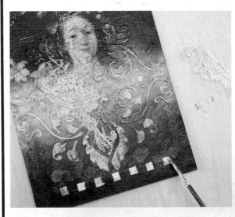

9 Prepare a Skin and use the scissors to cut it into squares (see Skins on page 46). Using a clean paintbrush and the polymer medium, adhere the lace and skin squares to the artwork. Let it completely dry. If desired, spray with spray varnish and let it dry.

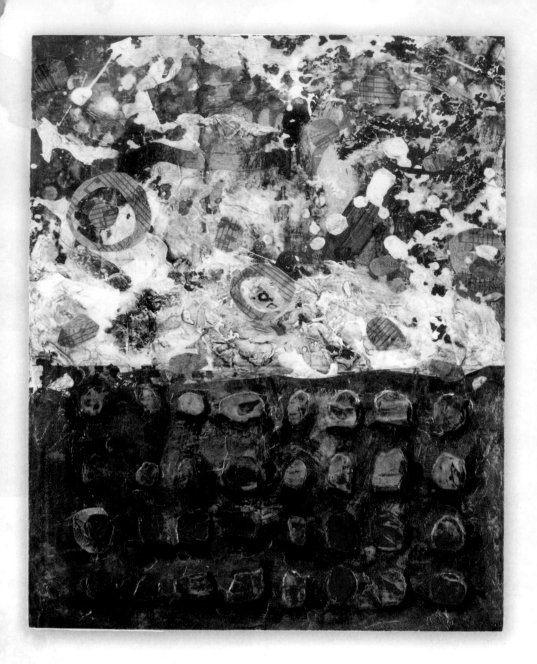

MATERIALS + TOOLS

paintbrushes

acrylic paints in black, white, orange, magenta, gold, silver, black glaze and interference green

surface

rubbing alcohol

gel medium, soft and heavy matte

stencil

palette knife

scissors

polymer medium

water

paper towels

sheet music

satin varnish spray

TECHNIQUES

Rubbing Alcohol

Stencil

Skins

Glazes

Unexpected Summer

By Sandra Duran Wilson

I always keep a surface nearby that I think of as my throwaway piece. This gives me the freedom to put anything on it. It usually starts with cleaning my brush from another project. I may then accentuate a shape or color.

This project started with loose gestures of contrasting colors; the circles represent nonlinear time, like the seasons. This piece is intuitive, not planned—each layer would "talk to me" and let me know what to do next. The eye does all the work of mixing the colors in the brain and detecting the layers.

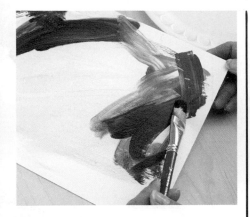

1 Paint the surface using gold, black and a small amount of the interference green with loose strokes to create an abstract background. Let the paint dry.

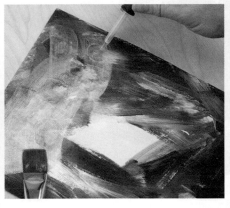

2 Apply silver paint in some areas, and spritz with rubbing alcohol (see Rubbing Alcohol on page 86). Let it dry.

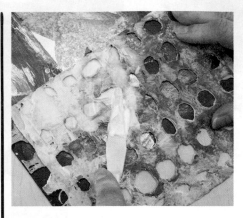

3 Use the palette knife to apply heavy gel (matte) through the stencil (see Stencil on page 14), and let it dry.

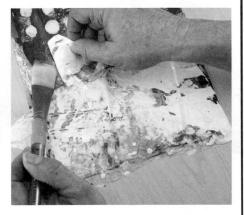

4 Prepare a skin using the soft gel and white paint (see Skins on page 46). Decide where and what part of the skin you want, and cut the skin as needed. Use polymer medium to adhere the skin to the surface.

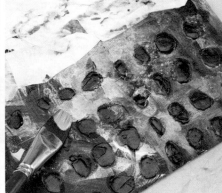

5 Paint magenta over the dried stencil shapes. Add some diluted gold to the bottom half of the background. Use a paper towel to wipe up some of the paint.

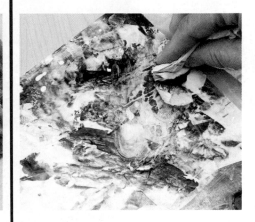

6 Prepare a glaze with black paint (see Glazes on page 74). Add the glaze over the surface to add depth, using a paper towel to wipe it away.

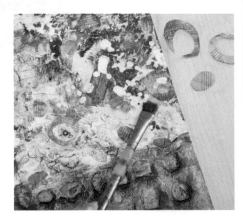

7 Paint a page of sheet music with the orange paint and allow it to dry. Cut it into shapes and adhere it to the surface using the polymer medium.

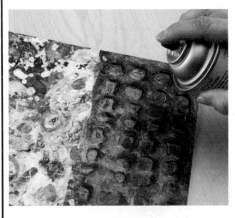

8 Spray the art with the satin varnish spray to unify the sheens and to seal the piece.

Resources

Check your local art supply retailer for these or similar supplies, or call the manufacturer directly to find a supplier near you.

GOLDEN ARTIST COLORS
www.goldenpaints.com
paints, gels, polymer medium and digital grounds

JOGGLES.COM
www.joggles.com
Tyvek

KRYLON
www.krylon.com
spray webbing and spray acrylic finishes

LAZERTRAN
www.lazertran.com
water-slide transfers

LIQUITEX
www.liquitex.com
paint, art supplies, gels and mediums

THIS TO THAT
www.thistothat.com
glue and adhesive questions

TRIANGLE COATINGS
www.tricoat.com
rusting and patina solutions

ART AND CRAFT SUPPLIERS:
Paint, tools, surfaces, metallic leaf, Krylon sprays, adhesives, collage paper, stamps and stencils

FABRIC STORES:
Fusible web

GROCERY AND DRUGSTORES:
Soap, salt, alcohol, plastic wrap, bleach pen, aluminum foil, petroleum jelly, shaving foam, parchment paper, rinse aid and supplies for making your own texture gels

HARDWARE STORES:
Sandpaper, foam rollers, masking tape, glue, plastic tarps, putty knives, ventilation tape, Venetian plaster and foam brushes

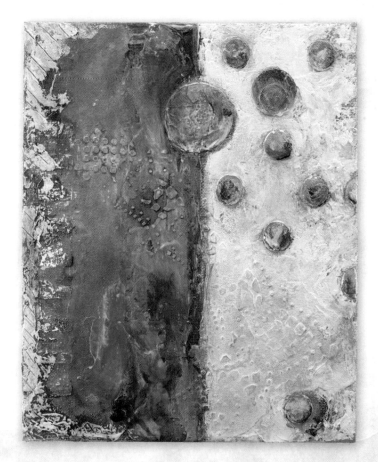

Index

More Ways to Explore Your Art

www.CreateMixedMedia.com
The online community for mixed-media artists

techniques • projects • e-books • artist profiles • book reviews

For inspiration delivered to your inbox and artists' giveaways,
sign up for our **FREE** e-mail newsletter.

Encaustic Workshop
By Patricia Seggebruch

Discover what happens when mixed media meets melted medium. In its purest form, encaustic painting is as simple as applying melted beeswax to an absorbent surface. In *Encaustic Workshop*, it becomes much more: a dynamic medium where anything goes and the possibilities are endless. Packed with step-by-step techniques, helpful tips and diverse examples of completed works, *Encaustic Workshop* brings all the accessibility and excitement of a mixed-media workshop to your own workspace.

ISBN-10: 1-60061-106-0

ISBN-13: 978-1-60061-106-3

Paperback with flaps; 128 pages; Z2089

EncaustiKits
Find them at www.ShopMixedMedia.com

Mixed-Media Paint Box
By **The Editors of North Light** Books

Incorporating paint into your mixed-media art has never been easier or more fun. Open up your paint box and delve into a year of creative ideas from 45 of your favorite artists. Whether you've used paint for years or have been anxious to try a new medium, you'll find great advice and ideas inside *Mixed-Media Paint Box*. Each week, you'll be guided with step-by-step instructions through a different project or technique that will add instant depth and drama to your art!

ISBN-10: 1-4403-0907-8

ISBN-13: 978-1-4403-0907-6

Paperback; 144 pages; Y0054

These and other fine North Light Books titles are available from your local craft retailer, bookstore, online supplier, or visit our website at www.ShopMixedMedia.com.

www.CreateMixedMedia.com
The online community for mixed-media artists